IMAGES
of America
GARDENA

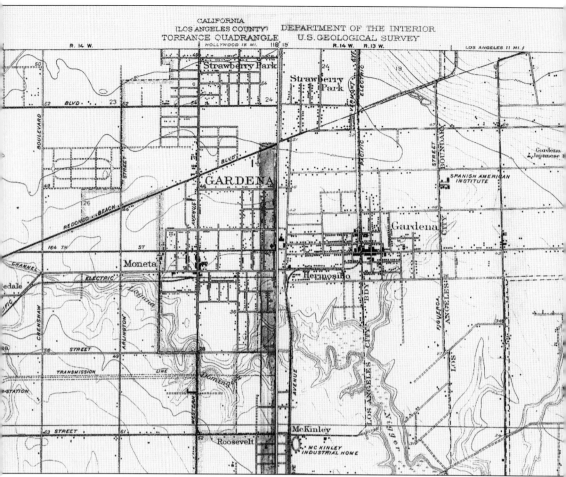

EARLY MAP OF GARDENA. This is an early cartographer's conception of the portion of Los Angeles County's South Bay that became the city of Gardena.

ON THE COVER: Young ladies are pictured picking berries on a Gardena farm in the early 1930s.

IMAGES of America
GARDENA

Gardena Heritage Committee

ARCADIA
PUBLISHING

Copyright © 2006 by Gardena Heritage Committee
ISBN 0-7385-4676-3

Published by Arcadia Publishing
Charleston SC, Chicago IL, Portsmouth NH, San Francisco CA

Printed in the United States of America

Library of Congress Catalog Card Number: 2006927529

For all general information contact Arcadia Publishing at:
Telephone 843-853-2070
Fax 843-853-0044
E-mail sales@arcadiapublishing.com
For customer service and orders:
Toll-Free 1-888-313-2665

Visit us on the Internet at www.arcadiapublishing.com

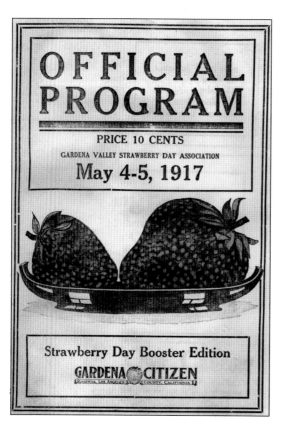

OFFICIAL PROGRAM. This photograph depicts the cover of the Gardena Valley Strawberry Day Association's Strawberry Days program, held on May 4 and 5, 1917. The program included a concert by the Gardena High School orchestra, an exhibit of livestock, a rabbit show, a poultry show, a gardening exhibit, an exhibition drill by local Boy Scouts, a baby show, a floral parade, Japanese entertainment, rodeo stunts, novelty races, a concert by Watson's Royal Scottish Pipe Band, free strawberries and the crowning of the Strawberry Queen. The program was printed by the *Gardena Citizen*, a publication that was advertised to be first with the news, first in influence, and first in advertising.

Contents

Acknowledgments 6

Introduction 7

1. Beginnings 9

2. Mid-Century 35

3. Cards, Cars, and Stars 65

4. Bet You Didn't Know 83

5. An "All America" City 103

ACKNOWLEDGMENTS

Images of America title *Gardena* was authored by the Gardena Historic Committee, which included Gardena city employees D. Christine Hach, Kelly Fujio, Pamela Amodeo-Morris, Anthony Gonzalez, Kim Nolan, and Ken Huthmaker, as well as interested citizens who were on the committee—Tom Parks, Paul Bannai, and George Castro.

The committee would like to thank the following people and organizations for their contributions: The Agajanian family (Cary, J. C. Jr., Chris), Arcadia Publishing, Betty Anderson, Faye Isobe-Anderson, Andy Bero, Robert Chapman, Cynthia Kawanami-Copeland, Donald Dear, John Fujikawa, Richard and Irene Furukawa, Rassie Harper, Gardena High School Library, Gardena Mayme Dear Library, Gardena Valley Chamber of Commerce, Don Graighton, Bruce Kaji, Gideon Katzer, Tokiko Tish Kawanami, Iku Kiriyama, George Kobayashi, Robert McColum, John Moore, Richard and Josephine Moore, Blaine Nicholson, John Nicholson, James Osborne, Arnold and Ann Ramirez, Rotonics Manufacturing, Ed Russ, Dave Schnorr, Ernie Urban, and the city clerk's office and archive. This book would not have been possible without them

INTRODUCTION

From archaeological digs around the South Bay area of Los Angeles, it is evident Gabrielino (Tongva) Indians hunted and fished in the area that would eventually become known as Gardena. The Gabrielino Indians (named for their association with Mission San Gabriel), were possibly the first people to set foot in Gardena and are believed to have descended from ancient hunters that crossed through the Bering Strait from Asia to North America as many as 10,000 years ago.

From early explorations along the coast of California by Juan Rodriguez Cabrillo in 1542 and later other Spanish explorers, all of California's lands eventually became vested in the king of Spain. Three years after the founding of Los Angeles in 1781, a Spanish soldier named Juan Jose Dominguez received, in recognition of his years of military service, thousands of acres. It was upon this land that he established Rancho San Pedro, part of which encompassed what would become Gardena Valley.

After the Civil War in 1869, Union army major general William Starke Rosecrans bought 16,000 acres in the Gardena Valley area, subdivided it, and sold much of it at a great profit. Another Civil War veteran, Spencer Roane Thorpe, bought a piece of the original Rosecrans property near 161st and Figueroa Streets. Other ranchers and farmers followed suit and purchased land in the Gardena Valley as well. Soon shops were opened and the town of Gardena was born.

Thorpe is credited with being the one to start the first settlement in Gardena in 1887. Some believe that Thorpe or perhaps his daughter named the settlement of Gardena from its early reputation as a "garden spot," because in the dry season it was the only fertile, green spot between Los Angeles and the sea, a lush oasis fed by waters from the Dominguez Slough.

Railroads put Gardena on the map near the end of the 19th century after the Los Angeles area underwent a tremendous real estate boom in 1886 and 1887. The Gardena Valley's first railway line, which ran from Agricultural Park in Los Angeles to the town site of Rosecrans (roughly halfway to Redondo Beach), was the Rosecrans Rapid Transit Railway, built in 1887 by real estate men Emil D'Artois and Walter L. Webb. After a year of intermittent rail service, in the summer of 1888, they discontinued their rail service. By the following spring, the railroad was bought and operated by the Redondo Railway Company. The company wasted no time building a roughly 20-mile rail line between Los Angeles and Redondo, which opened for business on April 11, 1890. The location of this new line prompted the moving of downtown Gardena from Figueroa Street to Vermont Avenue.

Japanese immigrants were a key part of Gardena's farming community during the town's early years, and their influence remains visible today. Many of the immigrants became nurserymen, gardeners, and farmers who tilled the vast, rich Gardena Valley soil into berry fields (mostly strawberries, raspberries, and blackberries grown year-round a century ago) and farms for the raising of tomatoes, alfalfa, and barley.

Because of its acres of berries, Gardena was dubbed "Berryland" and had the reputation as the berry capital of Southern California. It was especially well-known for its annual Strawberry Day Festival and Parade, held each May, when each visitor received a free box of strawberries. The

berry industry eventually fell off during World War I as other crops were cultivated for the war effort. Afterward, the community's development grew to eclipse much of the former farmland on which the berries were grown.

Gardena and the neighboring areas of Moneta and Strawberry Park became incorporated as the City of Gardena on September 11, 1930. Its new municipal status represented a response to the so-called "Alondra Park incident," an investment in a park site at Redondo Beach Boulevard and Prairie Avenue that threatened to burden taxpayers with a heavy county tax. When the incorporated towns of Inglewood, Hawthorne, Torrance, and Redondo Beach realized the enormity of the tax burden that the project would create, they pulled out, leaving unincorporated Gardena and its environs to shoulder the entire debt. The only way Gardena could protect itself was to incorporate.

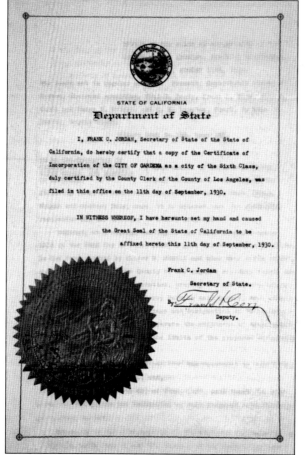

CERTIFICATE OF INCORPORATION. This document serves as a reminder of the so-called "Alondra Park incident," an investment in a park site at Redondo Beach Boulevard and Prairie Avenue that threatened to burden taxpayers with a heavy county tax. Other incorporated cities pulled out of the investment, leaving Gardena and its environs to shoulder the entire debt. This threat prodded the residents of Gardena to incorporate as a city.

One

BEGINNINGS

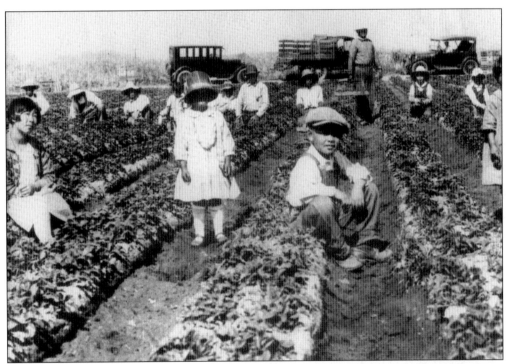

STRAWBERRY WORKERS. When it came time to pick strawberries, even the children helped out. Here workers in the early 1920s take a break from their labor in a strawberry field located in Moneta, which in 1930 became part of the incorporated City of Gardena. Around the Gardena Valley, oral history accounts indicate that the U.S. government tried to ensure that the crops would be harvested by offering to pay anyone who was willing to work the fields Japanese Americans had planted. Many of the individuals who applied for this program collected government stipends but had little knowledge of farming. In the end, most of them were unable to fulfill their charge and crops were lost. (Courtesy of Bob Ogawa.)

GARDENA RAMBLINGS. The *Gardena Ramblings* column by Tom Parks appeared regularly for many years in the Gardena Valley newspaper and was a favorite of many for its mix of history and humor.

Gardena RAMBLINGS
By TOM H. PARKS

They were the pioneers, the builders, the men and women who worked tirelessly to build a community and instill a sense of pride that still exists today.

They were the Rosecrans, the Carrells, the O'Havers, Purches, the Jeffers, the Spencers and John Hiram Bathrick.

Bathrick was born in Roscoe, Ill. on Aug. 28, 1845. At the age of 18 he joined the Illinois Infantry of the Union Army and fought in the Civil War. After the war ended the family moved to Iowa, where John became a cattle rancher.

Soon after returning from the war he was married and three children were born, Edward, William and Minnie Alice. His first wife died on Aug. 20, 1883.

Bathrick took a second wife, Elizabeth, and had two more children, Loretta and then John, who died shortly after birth.

The Bathrick family followed the calling of "Go west young man," and in 1902 moved to Gardena, where John bought a ranch on 182nd Street. Soon after, he bought a 10 acre parcel near Budlong and Gardena Boulevard from Charles Wallin.

In 1905 he built the first commercial building on Gardena Boulevard, west of Vermont. It was a two-story building, which housed a drug store and general store. The top floor was offered to organizations as a meeting place.

Before St. Anthony's Catholic Church was built, Mass was held at what had become known as "Bathrick Hall." The Masonic Lodge, of which Bathrick was a charter member, met for over 40 years in the hall. Today, the building, located at 1004 W. Gardena Blvd., is the Desert Room Cocktail Lounge.

John built a ranch and apple orchard on the 10 acre parcel he had bought. He built a home for the family help at 1157 W. Gardena Blvd., in 1911, which still stands today. Eventually John subdivided the land and sold lots for $300 each. He retained the home and his daughter, Loretta, lived there until 1977. She passed away in 1980 at the age of 93.

John's son, William, became a builder and helped build Jewel Union High School in 1906. It later became Gardena High and is now Peary Junior High School. William died in 1920.

His other son, Edward, married and had a son named Walter and a daughter, Marietta, better known as Mary. Edward and Walter built a home at 835 Alondra in 1922 which was then 923 W. Central. It was built for Dr. Paul McMath, who was an obstetrician and had offices at 904 Palm (Gardena Boulevard). The home was occupied by Dr. McMath for 60 years.

Minnie Alice, Bathrick's first daughter, married Benjamin Robert Simms. She died on Nov. 19, 1949, and is buried in Roosevelt Memorial Park.

Mary Bathrick never married. She was a career woman and was a charter member of the National Business and Professional Women, when the Gardena chapter was formed in January, 1932. Mary lived in a home on 163rd Street and New Hampshire until her death a few years ago. She remained active in the Gardena Valley YWCA until her passing.

John, affectionately called "daddy" by family and friends, lived to the ripe old age of 93 and died on June 21, 1939, at his home at 1053 W. Gardena Blvd.

The Bathricks were responsible for so much of the growth of Gardena, from the building of commercial buildings, the high school, the construction of St. Anthony's Church, the founding of the Masonic Lodge and many other achievements. Gardena would not have grown to be the proud community it is today without the pioneers like the Bathricks.

HISTORIC POSTCARD. This historic postcard depicts J. H. Bathrick and his six-year-old granddaughter Helen Bathrick getting ready to take a buggy ride. The two are seen at the 1100 block of Gardena Boulevard in 1908.

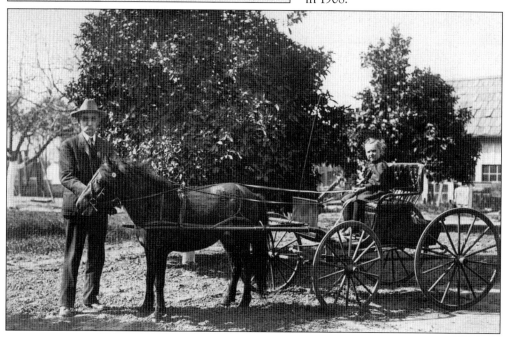

MAJOR GENERAL ROSECRANS. William Starke Rosecrans was born on September 6, 1819, in Delaware City, Ohio. He graduated fifth out of 56 in the class of 1842 from West Point. He commanded the 23rd Ohio Volunteer Infantry during the Civil War. After resigning from the army, he came to Southern California to invest in land and, in 1869, bought 16,000 acres of what became "Rosecrans Rancho" for $2.50 an acre. From the Rosecrans property, Gardena emerged. Rosecrans went on to become minister to Mexico, to represent California in Congress, and to serve as registrar of the treasury. Rosecrans died on March 11, 1898, and is buried at Arlington National Cemetery. VFW Post No. 3261 in Gardena was named in his memory.

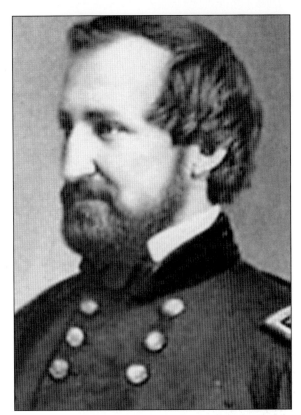

PIONEER HOMESTEAD. One of the first landowners of what would later become Gardena was Union army major general William Starke Rosecrans, who acquired his vast acreage in 1869. At one time, Rosecrans was asked to be a running mate for Lincoln's second election. This photograph shows his home, which was located on the southeast corner of Vermont and Rosecrans Avenues. The home was demolished in 1950.

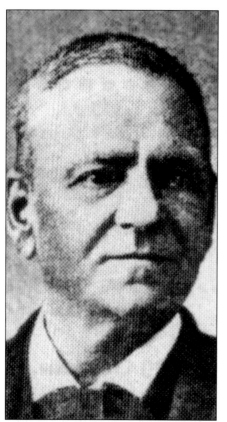

GARDENA FOUNDER. Spencer Roane Thorpe is credited with starting the first settlement in Gardena in 1887. He was born on January 20, 1842, in Louisville, Kentucky. At the age of 19, he left St. Joseph's College in Bardstown, Kentucky, to join the Confederate army. On July 9, 1863, Second Lieutenant Thorpe, Company A, 2nd Kentucky, was severely wounded in the shoulder and was unhorsed on the battlefield at Corydon, Indiana. With only a spark of life left in the young soldier, Thorpe was sent to a military prison at Johnson's Island. With an exchange of prisoners in October 1864, Thorpe rejoined his unit. Toward the end of the war, he was captured again, this time in Washington, Georgia. He was finally released at he end of the war. When the cry of "Go west, young man" echoed across the country, the 41-year-old Thorpe started looking for land to invest in. It is not known how he discovered the lush lands south of Los Angeles, but some believe it was through Maj. Gen. William Starke Rosecrans, who owned 16,000 acres in the area that covered much of the Gardena Valley. Thorpe bought a piece of that land in 1887. It was located at 161st and Figueroa Streets and adjoined the original Rancho San Pedro that was home to the Dominguez family. Other ranchers and farmers followed Thorpe's lead. Soon shops were opened, and Gardena was born.

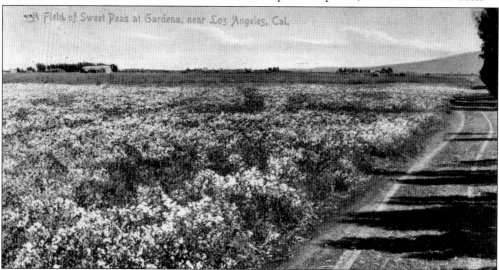

FIELD OF SWEET PEAS. John Bodger left England in 1891 to establish his seed business in California. In December 1904, he bought 160 acres in Gardena at a price of $113.31 an acre. His ranch in Gardena became known as the Sweet Pea Farm and sightseers came from far and near on the Pacific Electric Red Cars to see the acres of blooms. The family held the land until the early 1950s, when it was sold for a housing project. Today the Bodger seed business continues in Lompoc, California, and is famous for the giant American flag they grow out of flowers on their farm.

ROSECRANS LETTER. Pictured here is an 1893 letter from Colonel Rosecrans to S. R. Thorpe regarding the survey plot map of the Rosecrans tract and Gardena-tract boundary line.

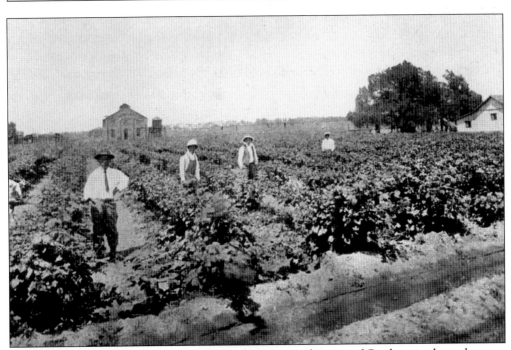

EARLY FARMERS. Strawberries and trucking farms were a big part of Gardena in the early years. Here some farmers pose on their Gardena land in 1912.

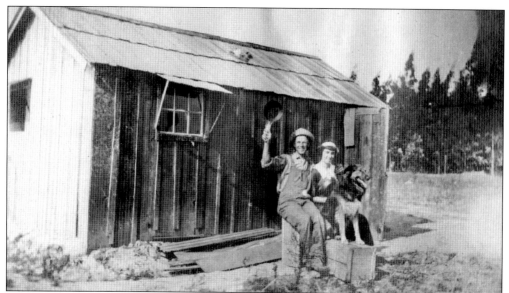

HARRY'S SHACK. Harry Buss and his friend Nellie Dickey clown for the camera in this 1912 photograph at his dairy ranch in Gardena. (Courtesy of James Osborne.)

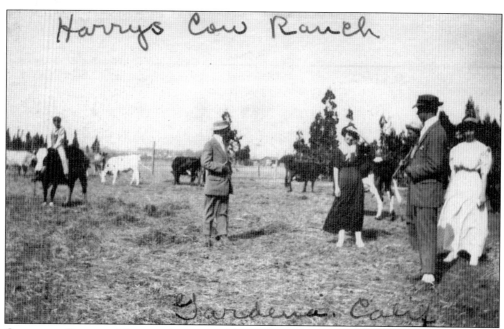

COWS FOR RIDING. The people pictured here in 1912 are riding cows and socializing on Harry Buss's cow ranch in Gardena.

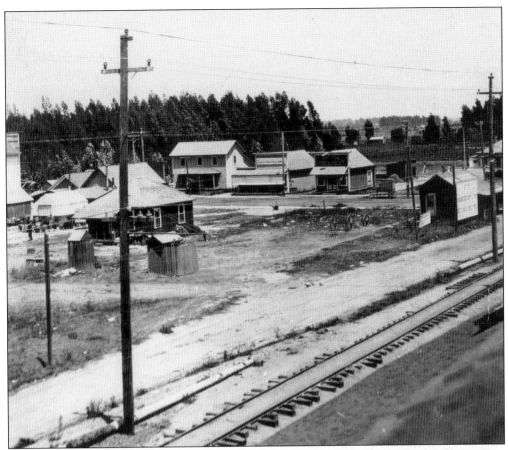

LOOKING NORTHEAST. This photograph, looking from 166th Street toward Western Avenue, was probably taken from the roof of the old tomato cannery. The railroad tracks still exist along 166th Street from Vermont Avenue west to the Crenshaw Lumber Company.

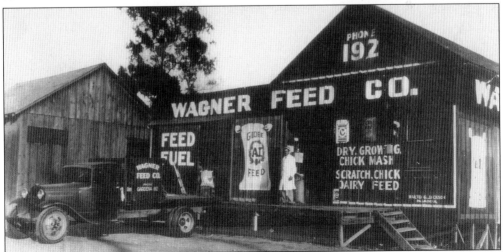

WAGNER FEED. Owner Joseph Wagner stands on the platform of his business located at 163rd Street and Vermont Avenue. This photograph dates to the 1930s.

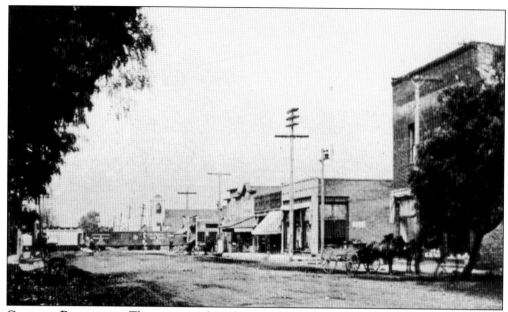

GARDENA BOULEVARD. This is a view of Gardena Boulevard looking east toward Vermont Avenue. Notice the railroad cars at the end of the image. That railroad crossing exists to this day.

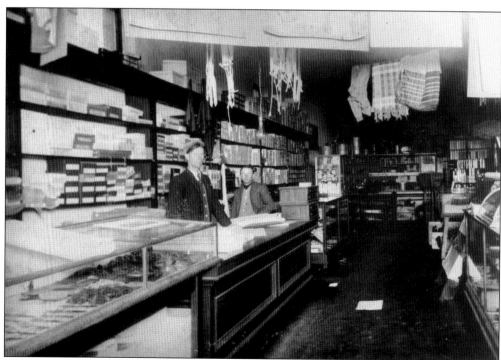

GENERAL STORE. Sales clerks pose inside the Wood and Graham general store. The store was a Gardena fixture back in 1906.

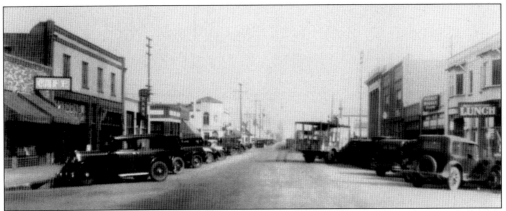

EAST TOWARD VERMONT. This view looks east along 165th Street (now Gardena Boulevard) in the days before incorporation. The white building on the northeast corner of Vermont Avenue still stands.

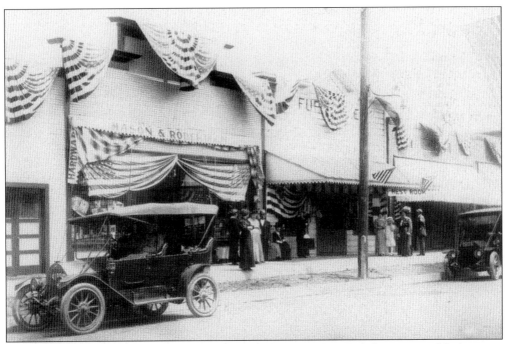

SHOPPING AREA. Businesses along old Gardena Boulevard included Mason and Robertson, Green's Furniture, the Fair Store, De Palma Jewelry, and Robertson's Grocery. Before there were gas stations in Gardena, Mason and Robertson had one pump to serve motorists at the edge of their sidewalk.

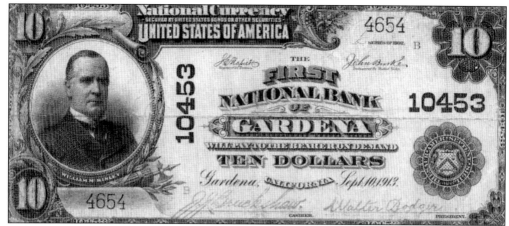

GARDENA MONEY. The First National Bank of Gardena once issued national currency. Bank president Walter Bodger signed this $10 note, issued on September 10, 1913. A prominent member of the community, Bodger has a park named in his memory at 14900 Yukon Avenue in Hawthorne.

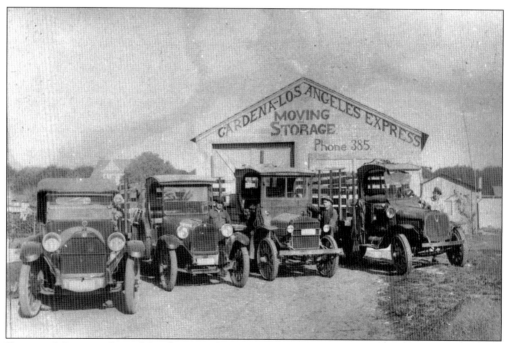

EXPRESS MOVERS. One of Gardena's earliest businesses was the Gardena–Los Angeles Express Moving and Storage Company. Workers with their trucks line up in front of the business in this old photograph. Note the three-digit phone number painted on the building.

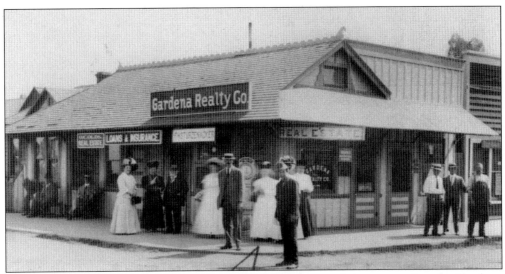

THE PLACE TO BE. From the group of people gathered around, it appears that the Gardena Realty Company was the place to be or at least the place to buy land in Gardena, Moneta, and Strawberry Park. The popular real estate company was located on what is now Gardena Boulevard. An advertisement for the real estate company can be seen in the 1911 edition of *The Tattler*, the Gardena High School yearbook.

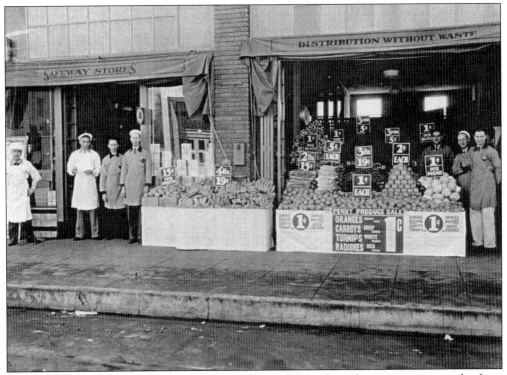

PENNY PRODUCE. This Gardena Safeway store sold produce for just one penny back in the 1930s.

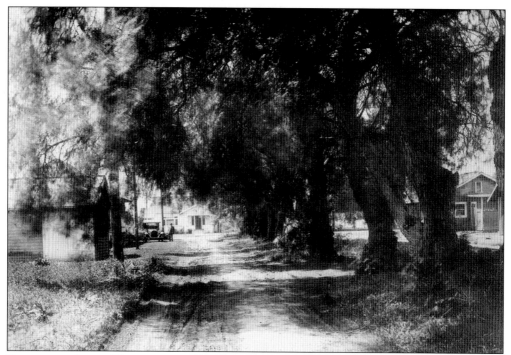

PEPPERTREE LANE. This is a view of Budlong Avenue looking north from Gardena Boulevard. Back in the 1930s, Budlong Avenue was known as Peppertree Lane.

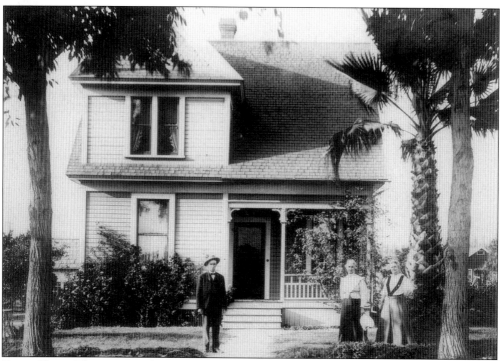

EARLY HOME. This two-story home stood at the corner of Budlong Avenue and Gardena Boulevard back before the days of incorporation. (Courtesy of John Moore.)

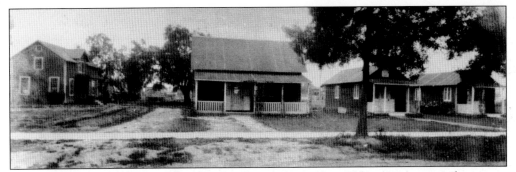

FIRST HOMES. These are some of the first homes located on Palm Avenue, now known as Gardena Boulevard.

BRICK HOUSE. This residence, which was located at 1212 Gardena Boulevard, was owned by Fanny E. Gray, who purchased the land in 1914. The home later became an attorney's office and home of the Pacific Asian Employment Consortium.

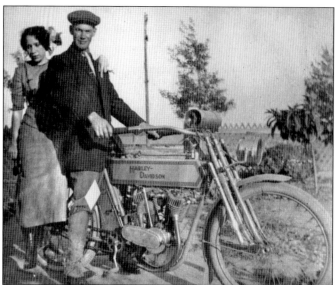

ENGAGING COUPLE. W. J. Simms and his fiancé pose on Simms's Harley-Davidson motorcycle in Gardena in 1912. The couple married two years later.

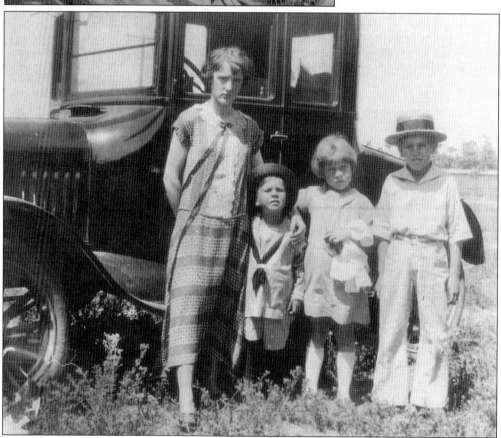

MOORE FAMILY. This family portrait was taken in 1925 and shows the Moore family near their home at 160th Street and Denker Avenue. Pictured here, from left to right, are Vera, Richard, Bernice, and Marvin Moore. Richard and his wife, Josephine, currently live at Leisure World in Seal Beach. Their son John Moore and his family still reside in Gardena.

OLD LIBRARY. The first public library in Gardena was located on East Gardena Boulevard. Two other libraries served local citizens, the little Strawberry Park Library and the Moneta Library, which was located near the present library at Gardena Boulevard and Western Avenue. The Gardena Library was born under the sponsorship of the Wednesday Progressive Club before the Los Angeles County Free Library was founded in 1912. In 1914, Gardena Library became a branch of the new county system. Only a few months later, the library was transferred to the jurisdiction of the Los Angeles City Library Board due to annexation. It was not until August 1951 that Gardena Library came back to the county system. The present 16,000-square-foot building was dedicated on December 5, 1964, and renamed Gardena Mayme Dear Memorial Library on May 30, 1992, in honor of the late Mayme Dear, who dedicated many years of volunteer service to the library.

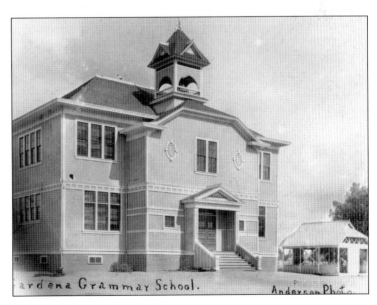

GRAMMAR SCHOOL. The Gardena Grammar School may well have been the first school in Gardena. The school was started in 1892 and was located on Main Street between Gardena Boulevard and 161st Street. (Courtesy of Anderson through the Gardena City Clerk's Office.)

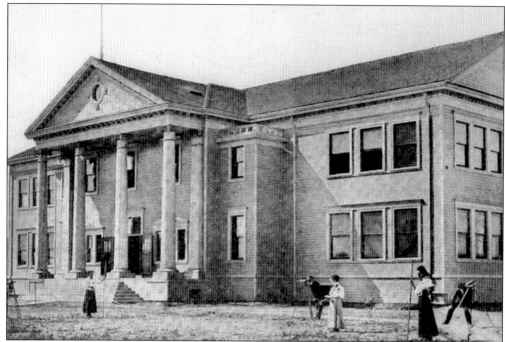

GARDENA HIGH SCHOOL. There were only 1,000 inhabitants in Gardena in the fall of 1904, when the city fathers decided to establish a high school. It was given the name of Jewell Union High School, and classes for students representing Gardena, Howard Summit, and Moneta were held in the Gardena Grammar School Building for the following two years. Mark Jacobs was the first principal, while Dan Towne, C. W. Stephenson, and Dr. J. F. Spencer served as the first trustees. As early as 1906, a need for expansion was evident and the city fathers floated a $20,000 bond issue for a separate high school. They bought five lots and erected this new building. A year later, Gardena High School became a part of the Los Angeles City School District as its third high school.

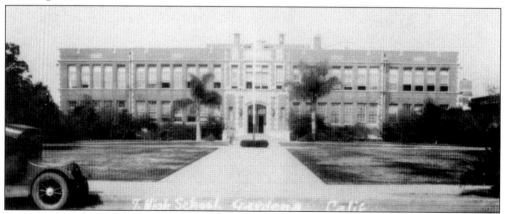

VINTAGE PHOTOGRAPH. Here is an image of Gardena High School taken in the 1930s. The building is now part of Peary Middle School. It's the same structure with a different face. The first high school classes in Gardena Valley were conducted in the Shellenberger building and later at the grammar school. The following year, in 1905, Jewel Union High School was established. An extensive building program from 1922 to 1934 resulted in this building on Normandie Avenue. Later the high school moved to its current facility at 182nd Street and Normandie Avenue.

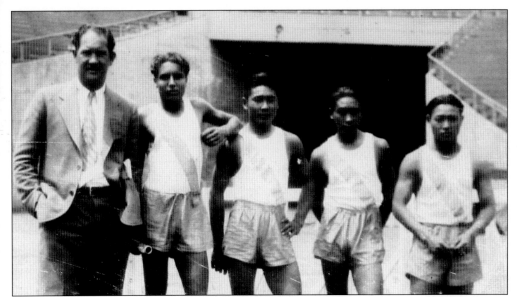

TRACK TEAM. Coach George H. Freeman and several members of his Gardena High School track team pose in the early 1930s. On the far right is Sam Ishihara, the oldest son of prominent businessman Henry Ishihara and his wife, Ei Nakamura Ishihara. Freeman Park, located at 2100 West 154th Place, is named in memory of coach Freeman.

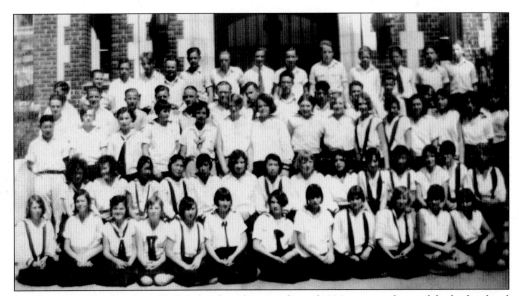

GRADUATES. The Gardena High School graduating class of 1930 poses in front of the high school administration building. (Courtesy of the Ishihara archive.)

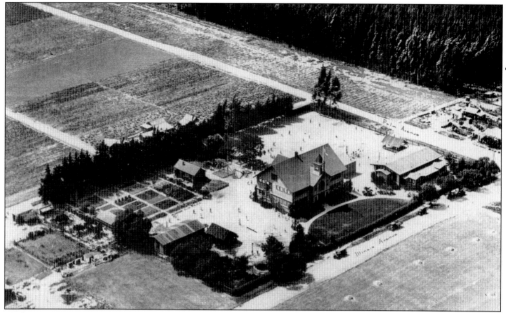

LANGUAGE SCHOOL. This is a 1925 aerial photograph of the Moneta Japanese Language School, located at the southwest corner of Gardena Boulevard and Gramercy Place. Before incorporation, this part of Gardena was known at Moneta; Gardena Boulevard was known as Palm Avenue; and Gramercy Place was known as Illinois Avenue. The Japanese Cultural Institute (JCI) now occupies the site where the language school used to stand.

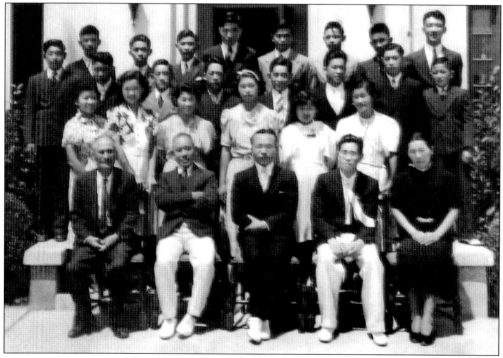

MONETA GRADUATES. These are 1938 graduates from the Moneta Japanese Language School. (Courtesy of the Ishihara archive.)

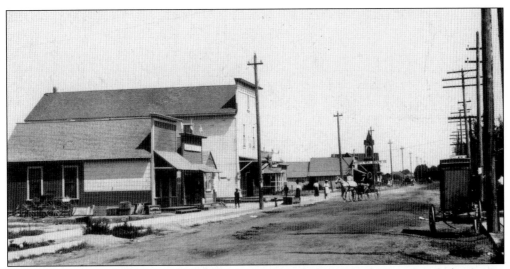

WESTERN AVENUE. This view shows Western Avenue looking north from San Pedro Street, now 166th Street. The church in the distance was the old Methodist Church that later became St. John's Lutheran Church and was moved to the corner of 163rd Street and Berendo Avenue. The building now houses a Korean Presbyterian church. St. John's has moved to Crenshaw Boulevard just south of Rosecrans Avenue and has become the home of the Gardena Senior Day Care Center.

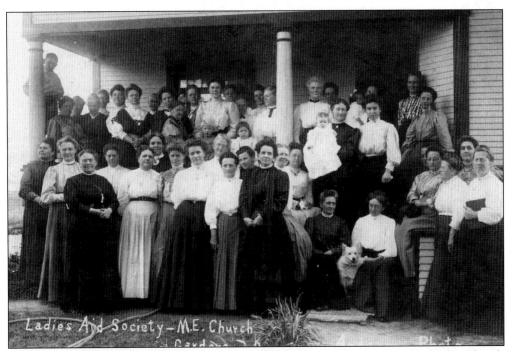

LADIES AID SOCIETY. The ladies pictured here were members of the Gardena Methodist Church Ladies Aid Society around 1910.

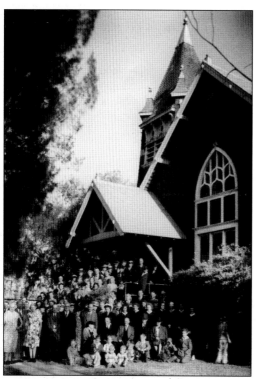

LUTHERAN CHURCH. The congregation at the old St. John Lutheran Church gathers for a photograph following the first service held at the church on March 25, 1926. The original church, located at Budlong Avenue and 163rd Street, is now a Korean church; the St. John Lutheran Church moved to 14517 South Crenshaw Boulevard. Their activities center became the home to the Gardena Senior Day Care Center.

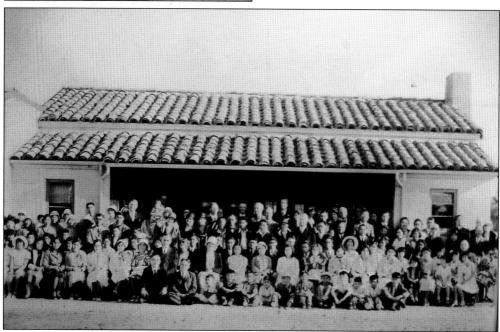

MONETA JAPANESE BAPTIST CHURCH. This church, which eventually became the Gardena Valley Baptist Church at 158th Street and Denker Avenue, was originally located in Moneta (now Gardena) at the corner of Gardena Boulevard and Denker Avenue. Members included Reverends Wada, Watanabe, Shirashi, and prominent Gardenan and Sunday school teacher May Koga (fourth from the right, front row).

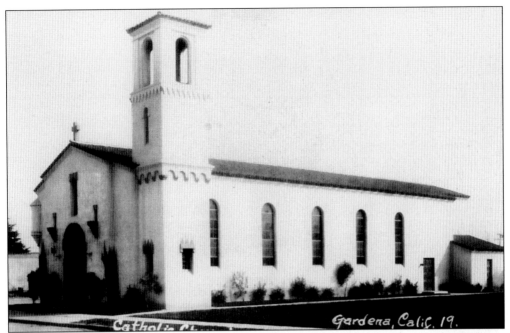

ST. ANTHONY CHURCH. This building, which still sits at the southwest corner of 163rd Street and New Hampshire, was the second St. Anthony of Padua Church building in Gardena. It served parishioners from 1927 until the dedication of the current building in 1967. The first church building was moved to 166th Street and Berendo Avenue for use as a Knights of Columbus Hall.

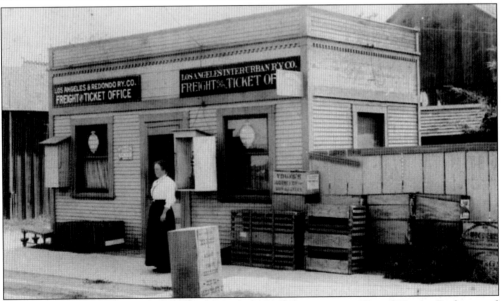

FREIGHT OFFICE. Gardena's first railway line was called the Rosecrans Rapid Transit Railway and was built in 1887. In the summer of 1888, Redondo Railway Company purchased the railway. The company built a rail line between Los Angeles and Redondo, which opened on April 11, 1890. This expansion prompted the moving of downtown Gardena from Figueroa Street to Vermont Avenue. Pictured here in the 1890s is the Los Angeles and Redondo Railway Company freight and ticket office in Gardena.

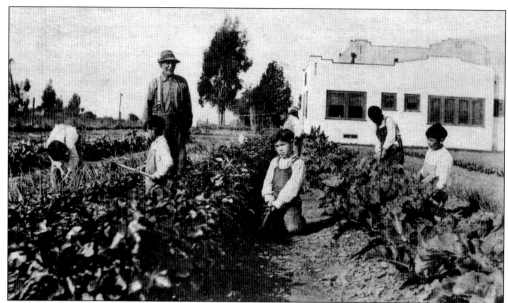

SPANISH AMERICAN INSTITUTE. From 1913 to 1971, the Spanish American Institute (SAI) taught industrial arts to Spanish-speaking boys. Located at 15840 South Figueroa Street in Gardena, the institute was one of Methodism's oldest institutions in the Los Angeles area. It had an illustrious history of service to the Spanish-speaking community in Southern California and served as a useful bridge between the churches of Mexico and the United States. SAI offered help and hope to boys and young men of Latin heritage. Many boys short on funds but long on ambition to make their lives count found in the institute a Christian home environment and the guidance and encouragement to live up to their best potential.

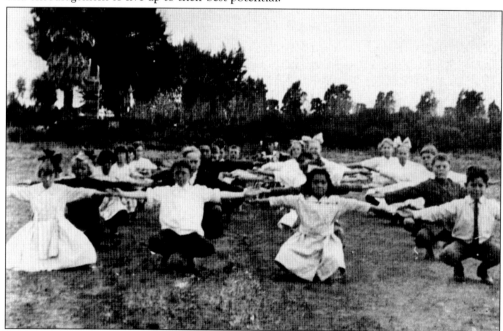

DAILY EXERCISE. Amestoy Elementary School children are pictured here in 1920 getting their daily exercise. Physical education was a big part of the school's curriculum in those days.

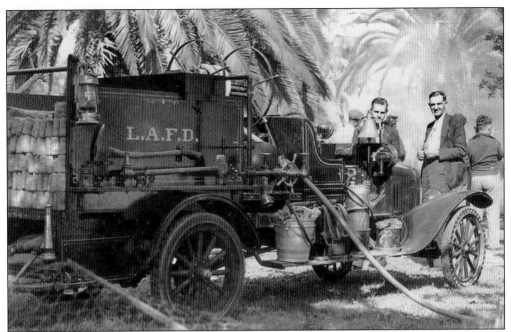

FIRE TRUCK. This is one of the first fire trucks put into service in Gardena. This old vehicle was one of a fleet of trucks operated by the Los Angeles Fire Department.

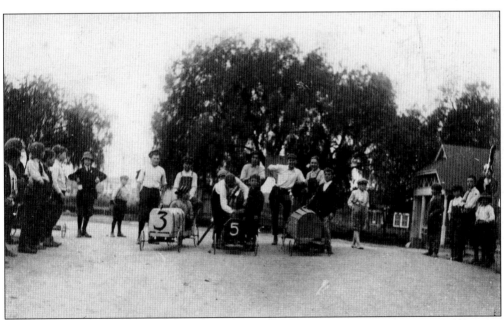

PUSHCARTS. Boys living in Gardena in the early days enjoyed racing their pushcarts in a forerunner of the world famous All-American Soap Box Derby. The Gardena Recreation and Human Services Department hosted several preliminaries to the derby on a small hill located along 178th Street between Western and Normandie Avenues in the early part of the 21st century. Winners of the local race earned points toward a chance to compete in the national race held annually in Akron, Ohio.

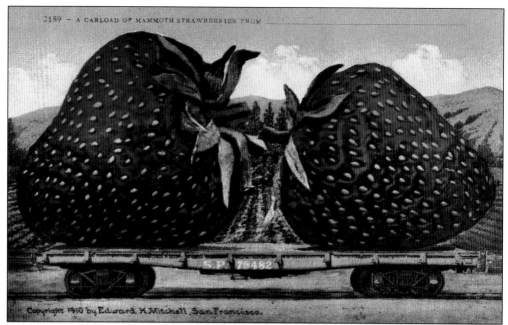

MAMMOTH STRAWBERRIES. This postcard announced the May 6, 1916, Strawberry Day Festival that was celebrated by the cities of Gardena, Moneta, Torrance, Bridgedale, Strawberry Park, Athens, Lomita, and Perry. Artist Edward H. Mitchell of San Francisco copyrighted the postcard in 1910. Mitchell was known for postcards showing large fruits and vegetables, such as a man holding a giant watermelon, and showing Southern Pacific Railroad cars loaded with huge figs, almonds, and strawberries, such as the ones seen here.

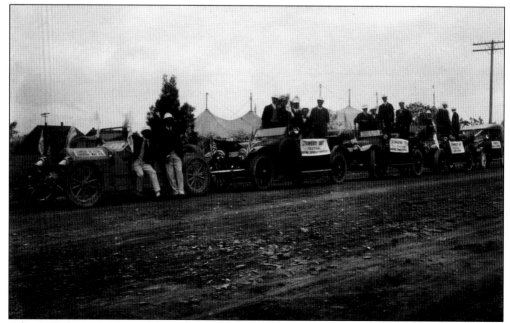

PARADE LINEUP. Cars and drivers line up along Gardena Boulevard for the 1914 Strawberry Day Festival Parade that was sponsored by the Gardena Chamber of Commerce. The festival took place on May 4 and 5 of that year and included a free automobile show.

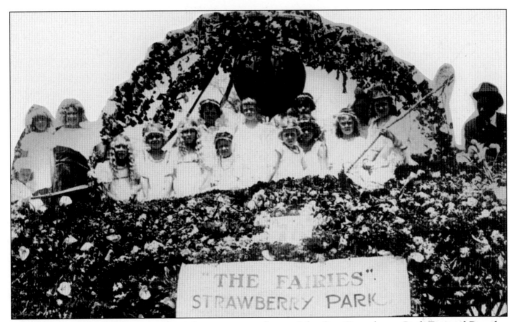

DECORATED FLOAT. This is a float that was part of one of the first Strawberry Park Festival Parades in Gardena; it carries a group of children depicted as "The Fairies." The float was made from a large wagon decorated with flowers and had a big red strawberry hanging in the middle of its canapé.

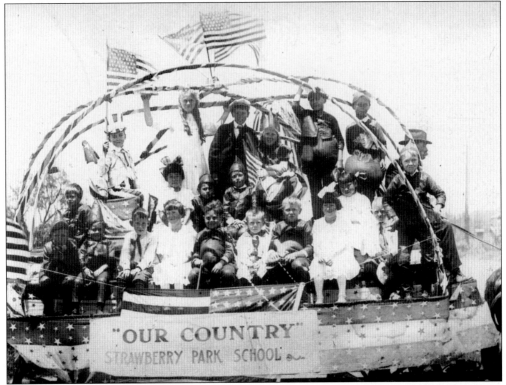

PARADE FLOAT. Children from Strawberry Park School take part in the annual Strawberry Park Festival Parade and celebration on this horse-drawn float called "Our Country."

MAYOR

WAYNE A. BOGART

FOR RE-ELECTION TO THE

GARDENA CITY COUNCIL

MUNICIPAL ELECTION
TUESDAY, APRIL 11th, 1944

THE RIGHT MAN FOR
AN IMPORTANT JOB

 12

MAYOR BOGART'S PROGRAM

1. To provide Post War Jobs for returning Service Men and jobs for our citizens now in war work.

2. Adequate recreational facilities with supervised activities for our young people.

3. Expansion of the municipal bus line.

BOGART FOR COUNCIL COMMITTEE
A. V. (BUD) ASHBROOK, CHAIRMAN
ED C. FLEMING, VICE CHAIRMAN

FIRST MAYOR. Wayne A. Bogart was the first mayor of Gardena, having been appointed in 1930 following the city's incorporation. He died in office in 1944, shortly after being reelected. He served as mayor for nearly all of his 14 years on the city council.

Two
Mid-Century

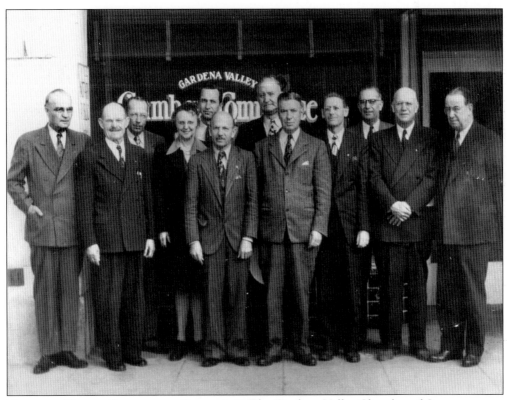

GARDENA VALLEY CHAMBER OF COMMERCE. The Gardena Valley Chamber of Commerce was organized in 1912 and had an important role in the growth of the city. The chamber of commerce was incorporated in 1932. This c. 1940 image shows future mayor Tom Ware on the far right. Also pictured, fourth from right, is James Gates, who later served as the Gardena postmaster.

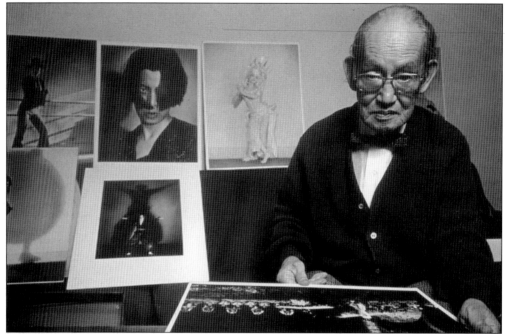

MANZANAR PHOTOGRAPHER. Photographer Toyo Miyatake was able to build a camera and take photographs inside the Manzanar Relocation Center during World War II. For many years, he and his family ran a successful photo studio on First Street in Little Tokyo, Los Angeles. Today his grandson Gary Miyatake carries on the family tradition with his Toyo Photography Studio, located on Gardena Boulevard just east of Normandie Avenue.

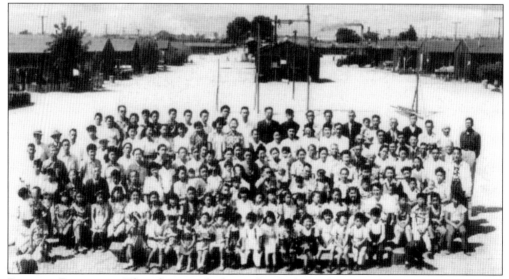

BLOCK 8 RESIDENTS. This photograph shows the residents that were living in Block 8 at the Manzanar Relocation Center on May 5, 1945. Gardena resident Irene Sanaye Takenaka and the Takenaka family are all depicted this photograph, a portion of which can be seen near the entrance to the new Manzanar Museum, which was dedicated on April 24, 2004. Irene's father, Roy Yasuo Takenaka, was an expert tennis player and formed a tennis club that practiced on a tennis court that Roy built adjacent to his family's living quarters between Block 8 and Block 14.

FAMILY PORTRAIT. Irene Sanaye Takenaka Furukawa of Gardena sits on her grandmother's lap for a family portrait taken at the Manzanar Relocation Center in 1944. Also in the photograph, from left to right, are (sitting) grandmother Maria Sei, Irene Sanaye, brother Tommy Tatsuo and brother Roy Seichi; (standing) Irene's mother Alice Shigeko, father Roy Yasuo Takenaka, sister Bernadette Yoko, grandfather Harry Kiuju, sister May Yuriko and uncle John Makoto. Irene and her husband Richard Furukawa have lived in Gardena since 1972.

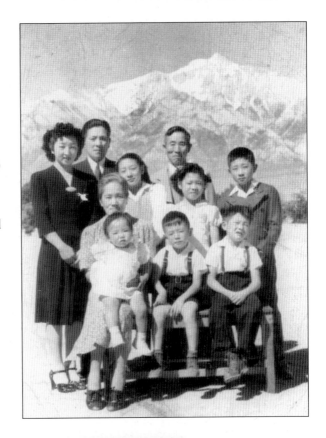

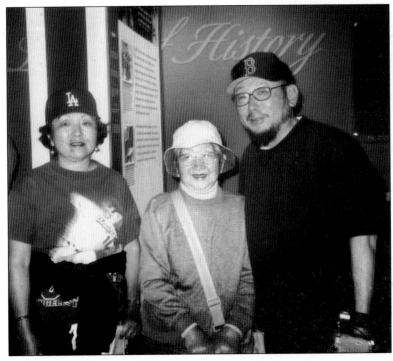

RETURN TO MANZANAR. Irene Sanaye Takenaka Furukawa of Gardena returned to the Manzanar Relocation Center with her mother, Alice Shigeko, and her husband, Richard Furukawa, on April 24, 2004, to attend the opening of the new Manzanar Museum. The family stands in front of a display board that features a photograph of Irene when she was a baby in Manzanar in 1944.

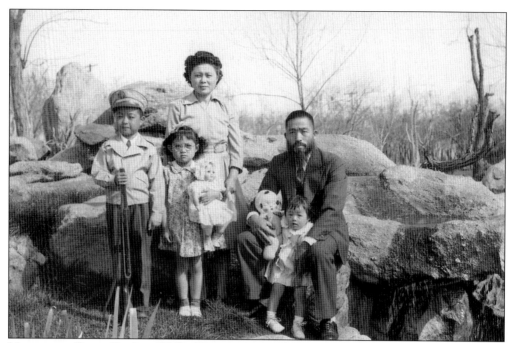

Manzanar Park. Gardena Wall of Fame recipient Iku Kato Kiriyama spent the war years with her family at the Manzanar Relocation Center near Lone Pine, California. She is pictured here with her family wearing glasses and holding a favorite doll. Family members included here, from left to right, are brother Roy, Iku, mother Shizuko, father Takashi, and sister Aiko Kato. The family is sitting in a Japanese garden located at Manzanar Park on March 17, 1945.

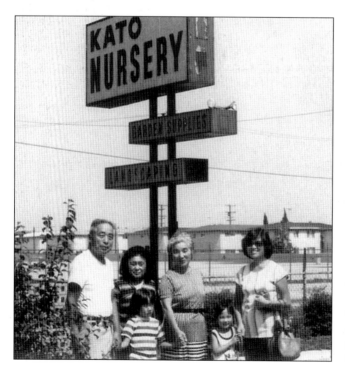

Nursery. For many years after the war, the Katos ran a nursery at 1650 Artesia Boulevard in Gardena. Pictured here at the nursery, from left to right, are Takashi and Shizuko Kato, grandson George Kiriyama, Nobuko Sasaki (a friend from Japan), granddaughter Traci Kiriyama, and Iku Kato Kiriyama.

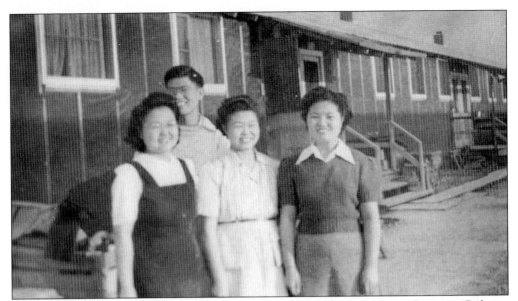

INTERNMENT. The Sugi family from Gardena was sent to the Relocation Center in Rohwer, Arkansas, during World War II. Standing in front of their barracks in 1943 are, from left to right, Miyoko, Yoshi, Haruko, and Fusako Sugi. Later Yoshi served in the U.S. Army and Haruko served in the Women's Army Corps. While the Sugis were away, a family friend took care of their home in Gardena until they returned after the war. Haruko and Fusako Sugi still live in the old family home.

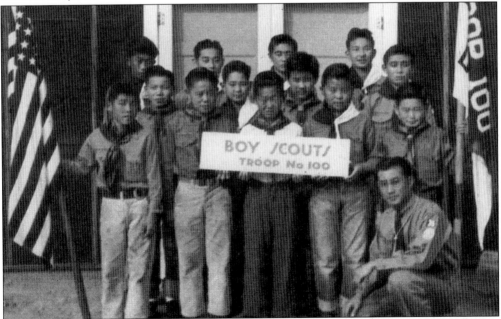

MEMORABLE TRIP. Gardena Boy Scout leader Roy Mayeda, of Troop 719, remembers his first scout camping trip. It was the first time he was able to leave the confines of the Jerome Relocation Center in Denson, Arkansas, where his family was interned during World War II. Mayeda, as a Boy Scout, stands in the first row to the far right. The photograph of his troop was taken on November 25, 1943.

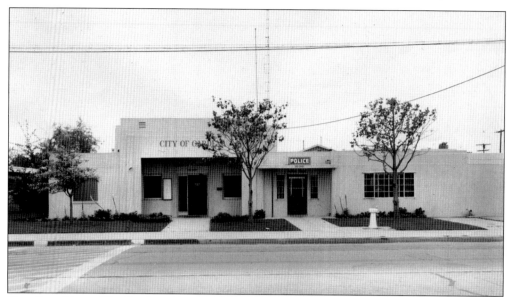

OLD CITY HALL. The Gardena City Hall and police department were located where the current fire station on 162nd Street is located today. This photograph was taken in the late 1950s.

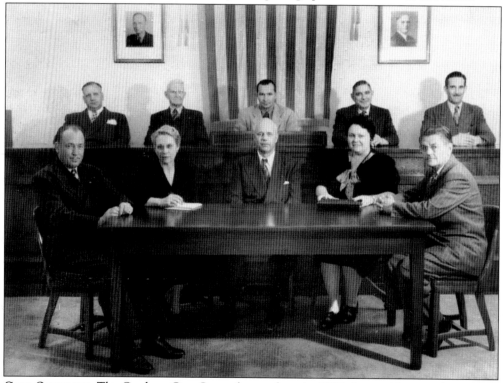

CITY OFFICIALS. The Gardena City Council poses here in 1946 along with some department heads. Pictured here, from left to right, are (first row) city engineer Harold Barnett; chief deputy city clerk Eunice K. Larrimer; city treasurer Frederick W. H. Van Oppen; city clerk Lucille W. Randolph, and city attorney Lester O. Luce; (second row) James L. Rush, Fred O'Haver, Mayor Adams W. Bolton, Earl P. Powers, and Adolph L. V. Plattky.

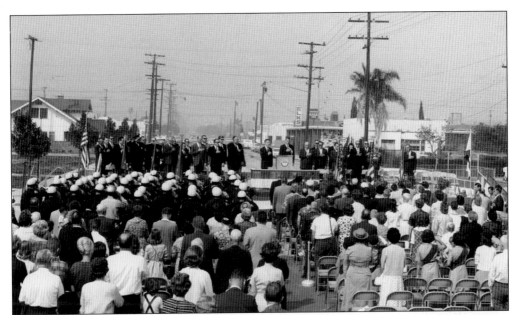

CIVIC CENTER DEDICATION. The dedication of the new city hall and civic center took place in the middle of the 1700 block of 162nd Street in 1963. Serving on the city council at the time were Mayor L. Pete Jensen, mayor pro tem Robert Firstman, and councilmen Robert Kane, Donald Davidson, and Harvey Chapman. Also officiating were city clerk Lucille Randolph, city treasurer Sidney Lemberger Jr., and the city's first administrative officer Paul Rowley. Future councilman Vince Bell, commissioner William Gerber, and school superintendent Bill Johnson can also be seen on the platform.

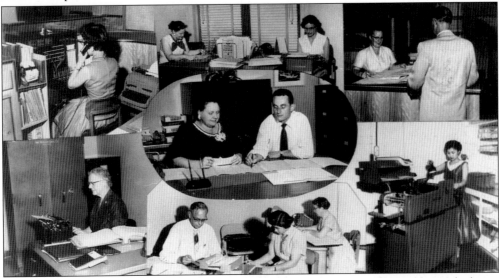

CITY CLERK'S OFFICE. These are the city hall offices in August 1955. Pictured here, clockwise starting from the upper left, are switchboard operator Flora Yamada, secretary to the city attorney Catherine Miller, clerk Lillian Baldock, clerk to the planning commission Emma Bitetti, city administrator Paul A. Rowley, multigraph operator Flora Yamada, accountant Marian Vuurman, clerk Alice Tsukahara, Paul A. Rowley, and deputy city treasurer Geraldine Gleerup; in the center are Lucille Randolph and administrative assistant Gene Asmus.

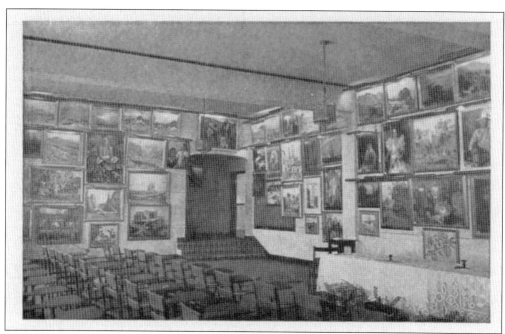

ART COLLECTION. The Gardena High School art collection began with a gift of a single painting purchased by the high school senior class of 1919. This practice continued in subsequent years, flourishing into a major art collection for the school. Pictured is a corner of the 1936 art exhibit.

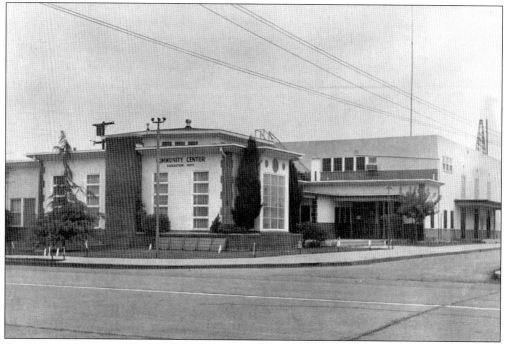

COMMUNITY CENTER. The Gardena Community Center, formerly a teen center, is pictured here in 1958. The building was located at the corner of 162nd Street and La Salle Avenue and was replaced by the human-services offices and Rush Gymnasium.

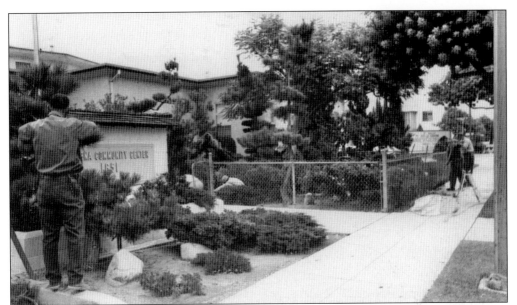

JAPANESE GARDEN. A worker puts the finishing touches on the Japanese garden sign at 1651 West 162nd Street. The garden enhanced the entrance to the original community center. The garden is still in the same location, but the community center has moved across the street to 1670 West 162nd Street, and in its place is the new Rush Gymnasium parking lot.

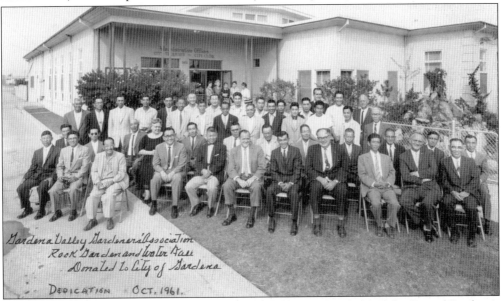

GARDEN DEDICATION. The rock garden and waterfall, located in front of the City of Gardena's former administrative offices, were dedicated in October 1961. Attending the dedication were the members of the Gardena Valley Gardener's Association that did the construction and some city officials, including city clerk Lucille Randolph, city treasurer Bruce Kaji, councilman Robert Kane, Mayor L. Pete Jensen, and director of parks and recreation Al Nash. The Japanese garden remains, but the administrative office was demolished. In its place sits the offices of the human-services division and the Rush Gymnasium, named in memory of former mayor and city councilman James Rush.

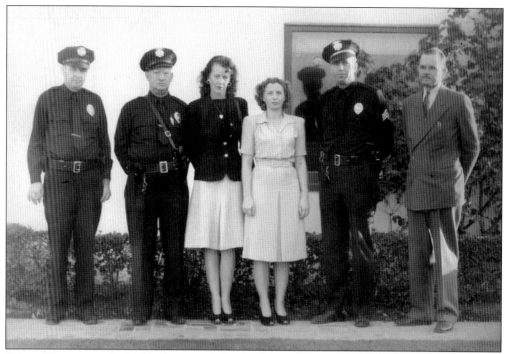

POLICE DEPARTMENT. In 1947, some of the members of the Gardena Police Department pose for this photograph. Pictured, from left to right, are Carl C. Grove, Floyd E. Hammond, LaVerna Peterson, Emelia Bois Turner, Sgt. Roy E. Tracey, and Chief Elmo W. Field.

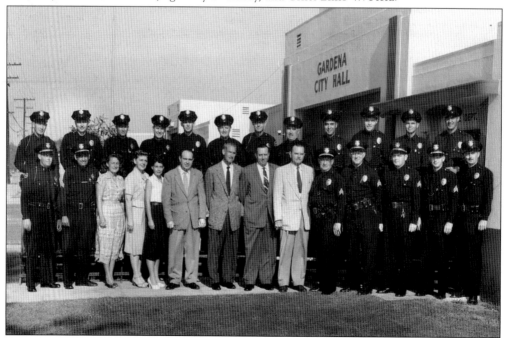

GARDENA'S FINEST. The entire Gardena Police Department poses for this photograph, taken in 1955 in front of the old city hall. Chief Elmo Field is pictured in the first row sixth from the right.

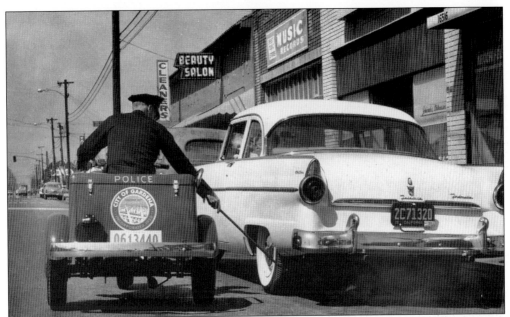

LIMITED PARKING. A Gardena police officer tags a car parked along Western Avenue in 1955. Note the Kingdom Hall for Jehovah's Witnesses in the background. The church later moved to it present location on Gardena Boulevard just east of Normandie Avenue.

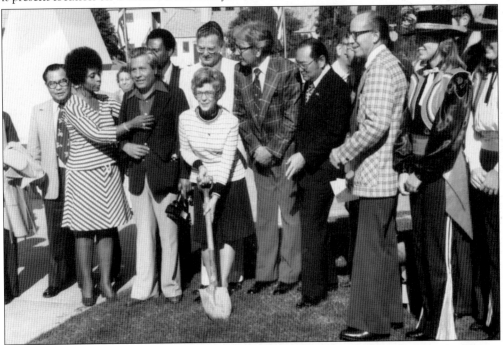

TIME CAPSULE. A time capsule was buried near the front of the Gardena Community Center in 1975. Among those taking part in the ceremonies, from left to right, are former mayor Kiyoto "Ken" Nakaoka, human-services commissioner Kai Parker, senior-citizen commissioner George Castro, Mayor Ed Russ (rear), bicentennial committee chairwoman Lois Johnson (holding shovel), planning commissioner William Gerber, California state assemblyman Paul Bannai, councilman William "Bill" Cox, and members of the Los Caballeros Band.

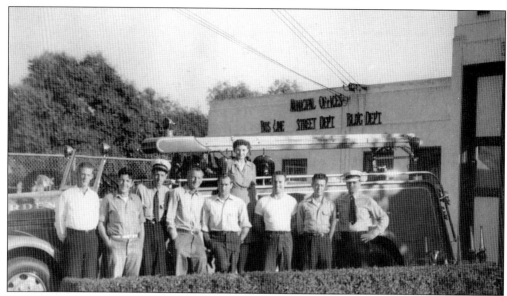

FIRE DEPARTMENT. Members of the Gardena Fire Department pose for this photograph in 1947. Pictured from left to right are Capt. Carl Carlson, who became chief in the 1960s; Capt. Charles T. Townsend; Capt. Charles Miller; George E. Grande; Thomas J. Vales; Carolyn Lentfer, secretary; Harold Larson; Rex. B. Monson; Joseph A. Krumme; and Chief George C. Springstead. Not pictured are Ivan L. Hopkins and Randell Keith Parlett.

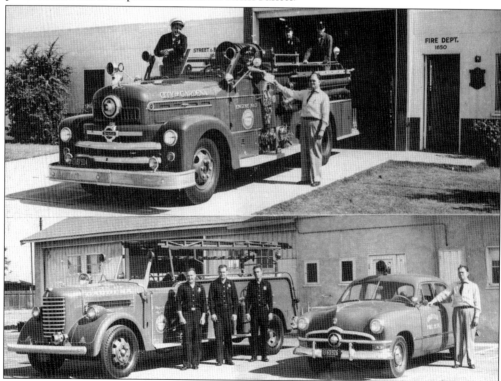

FIRE TRUCKS. In 1955, the Gardena Fire Department was located at 1650 Gardena Boulevard. Pictured here are members of the department with Chief Charles C. Springstead.

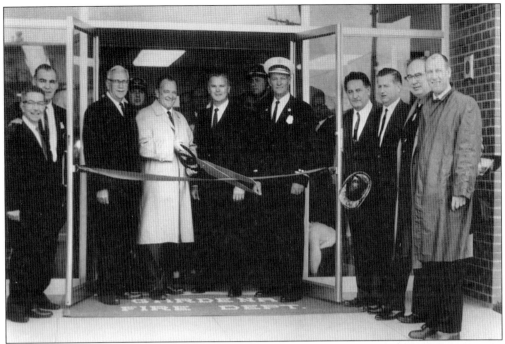

NEW FIRE STATION. In 1964, Gardena's new fire station opened at 1650 West 162nd Street. Mayor Robert Kane (holding scissors) officiated the ribbon-cutting ceremony. Pictured from left to right are city treasurer Sidney Lemberger Jr., former councilmen Alex F. Bero and James Rush, Kane, unidentified, fire chief Carl Carson, unidentified, unidentified, and councilmen L. Pete Jensen and Harvey Chapman.

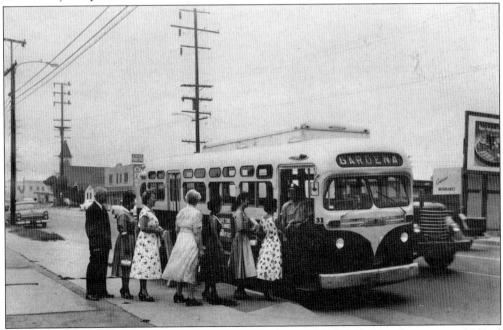

ALL ABOARD. Gardena citizens are pictured boarding a Gardena bus at the corner of 162nd Street and Western Avenue in 1955.

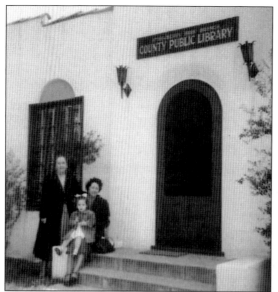

OLD LIBRARY. In 1942, the Strawberry Park Branch Library was located at 1218 Compton Boulevard (now Marine Avenue). The building is currently a private residence. Branch librarian Helen McGee announced that when all the Japanese residents were evacuated during the war, every Japanese borrower returned their books and paid every fine. McGee is seen here standing in front of the library with her sister and granddaughter.

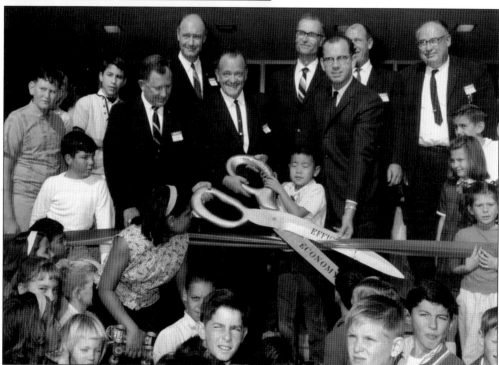

LIBRARY DEDICATION. Taking part in the ribbon-cutting ceremonies during the grand opening of the new Los Angeles County Library in Gardena, located at 1731 West Gardena Boulevard are, from left to right, councilmen Robert Firstman and Donald Davidson, Mayor Robert Kane, Los Angeles County supervisor Kenneth Hahn, councilmen Harvey Chapman and L. Pete Jensen, and dozens of local youngsters waiting to use the library. Dedication ceremonies took place on December 5, 1964. At that time, the library was the largest ever constructed in any city by the County of Los Angeles. It is built around a Japanese interior court garden, designed and landscaped by members of the Gardena Valley Gardener's Association.

DELIVERY TRUCK. Joe Wagner leans against the Wagner Feed Company delivery truck. The Wagners owned a five-acre ranch, complete with cows and horses, at 16900 South Main Street.

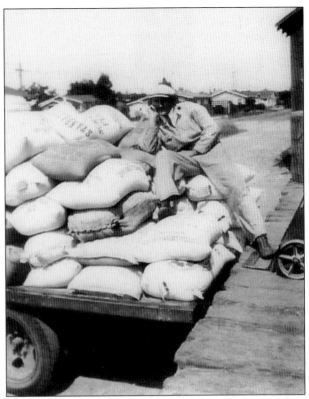

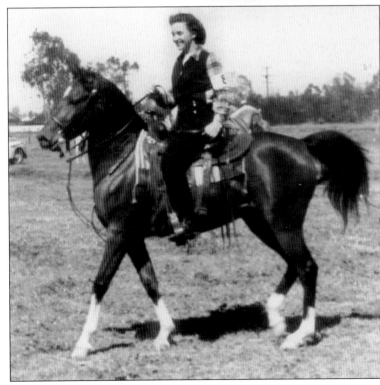

ON HORSEBACK. Josephine Wagner enjoys herself horseback during the Gardena Fair on April 24, 1948.

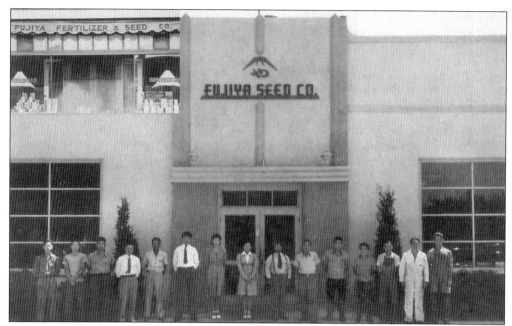

SEED COMPANY. The Fujiya Seed Company in Moneta (now Gardena) was the largest Japanese-owned business in the area before World War II. The company was originally located in the 16500 block of Western Avenue (the inset building still exists) but later moved to 1440 West 166th Street. The owner, Toshiji Ishihara, is pictured sixth from the right; his oldest son, Sam, is pictured fourth from the left; the second-oldest son, Sakae, is third from the left. Other prominent Gardenans that worked for the company were Mas Fukai's sister Tsuyoko, eighth from the left, and Gardena Wall of Fame honoree Fred Adam to the far right.

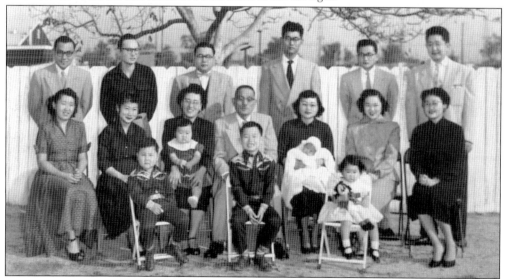

THANKSGIVING DAY. Fujiya Seed Company founder Toshiji Ishihara (second row, center) poses with his family in the backyard of the family home on Walnut Street (now 163rd Street) on Thanksgiving Day 1952. Pictured, from left to right, are the following: (first row) Dorothy, Fumi, John, Rose, Pat, Toshiji, Tom, Tokiro, Cynthia, Isabel, Trude, Mitsuko; (second row) Roy, Sakae, Sam, Kiyoshi, Hank, Richard.

ST. ANTHONY SCHOOL. Students at St. Anthony Elementary School sit for this formal school photograph taken in the early 1940s. (Courtesy of Martin Almaraz.)

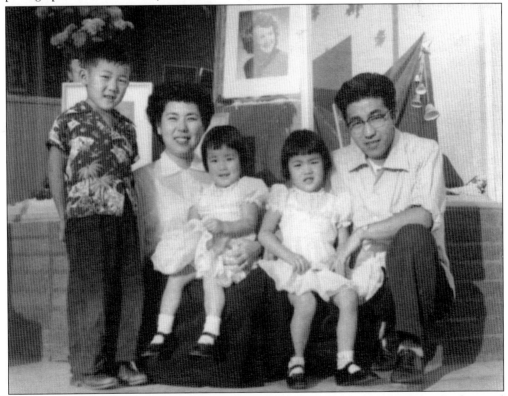

FAMILY PHOTOGRAPH. For many years, Tak Isobe ran a successful portrait studio in Gardena and was the official photographer for Gardena High School doing the school's senior portraits and yearbook photographs. The family pictured here, from left to right, are Craig, Kikue, Donna, Linda, and Takeo. They are posing in front of the Isobe Photo Studio, located on Gardena Boulevard in 1951. (Courtesy of Faye Isobe.)

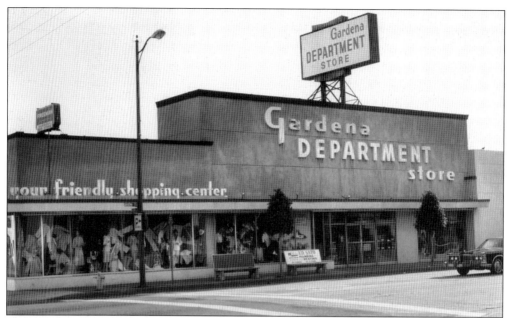

SHOPPING CENTER. The Gardena Department Store at 1105 West Gardena Boulevard was known as "your friendly shopping center" back in the 1950s. The store is still in business today.

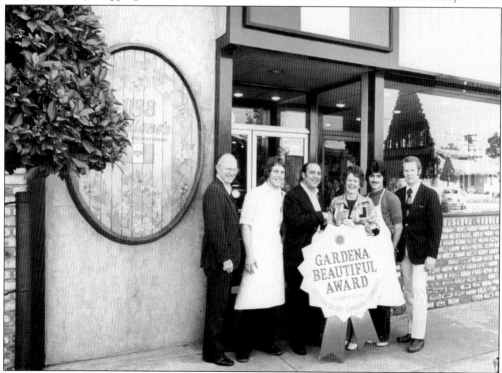

BEAUTIFUL AWARD. A remodeled Giuliano's Deli receives a beautiful award from the Gardena Valley Chamber of Commerce. Chamber representatives Anita Bell and Bob Chapman present the award to Bob Giuliano. Giuliano's Deli has been a landmark business in Gardena for well over 50 years.

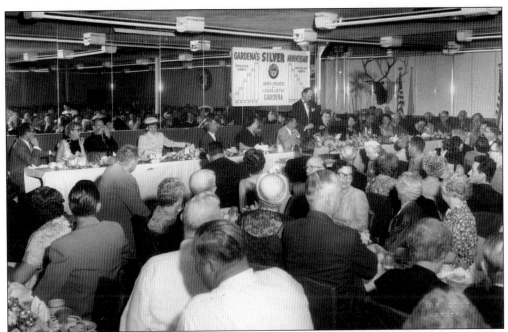

SILVER ANNIVERSARY. The City of Gardena celebrated its 25th anniversary with a dinner at the Gardena Elk's Lodge in 1955. Former mayor Donald Davidson served as master of ceremonies.

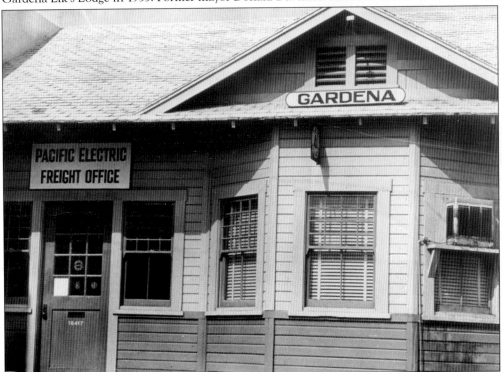

BIG RED CARS STATION. The Pacific Electric trains stopped in Gardena on a regular basis. The company's freight office was located on the northwest corner of Gardena Boulevard and Vermont Avenue. The building was torn down in the early 1960s.

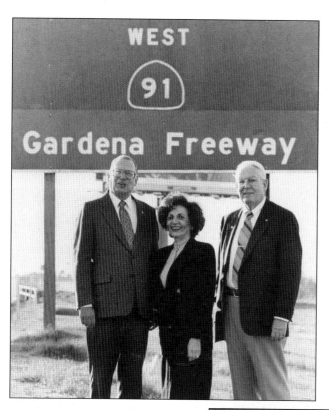

Freeway Sign. Celebrating the installation of the Gardena Freeway sign along the 91 Freeway leading to the Artesia Boulevard corridor in Gardena are Mayor Donald Dear, Sen. Ralph Dill's administrative aide Rose Sarukian, and city councilman James Cragin. The Gardena Freeway is a short thoroughfare in south Los Angeles County that is the westernmost freeway portion of California State Route 91. It begins just west of the Harbor Freeway at the eastern edge of Gardena, proceeding eastward approximately six miles until it intersects the Long Beach Freeway.

Russ Interchange. Bridge 53-958, the Interstate 110/Route 91 interchange, is named the Edmond J. Russ Interchange for the mayor emeritus of Gardena. Russ worked diligently during his time as mayor to extend the Redondo Beach Freeway (Route 91) to interchange with Interstate 110. After approval, the interchange was erected in 1985 and named after the former mayor. With help from the *Gardena Valley News*, donations were collected to purchase and install signs depicting the name of the interchange in 1999.

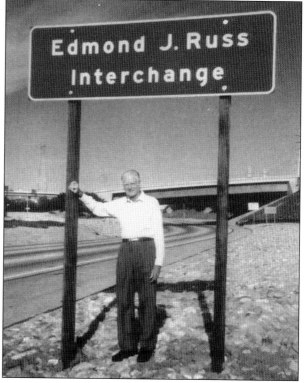

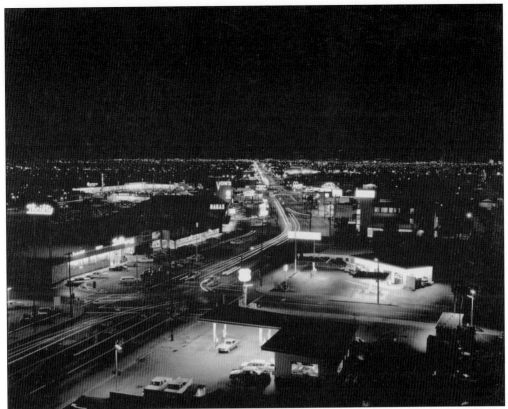

GARDENA AT NIGHT. A beautiful nighttime view of Redondo Beach Boulevard looks west from the roof of the Memorial Hospital of Gardena in the late 1960s. (Courtesy of George Castro.)

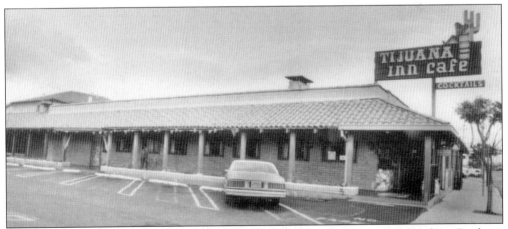

LANDMARK RESTAURANT. For many years, the Tijuana Inn Café was a landmark in Gardena. It was located just east of Memorial Hospital, where a medical center exists today. The restaurant was owned and operated by Vincent and Anna Arias, their children, and eventually their grandchildren.

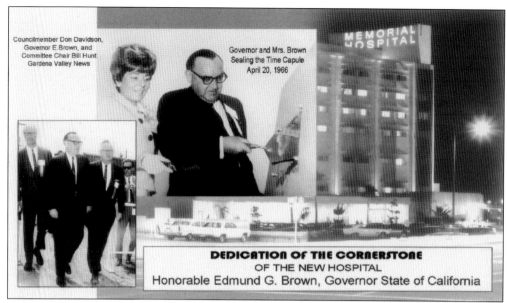

A SEALING. Governor and Mrs. Pat Brown had the honor of sealing the time capsule placed at the Memorial Hospital of Gardena on April 20, 1966. Arriving with the governor (small inset) are Mayor Donald Davidson and *Gardena Valley News* copublisher William "Bill" Hunt. (Courtesy of George Castro.)

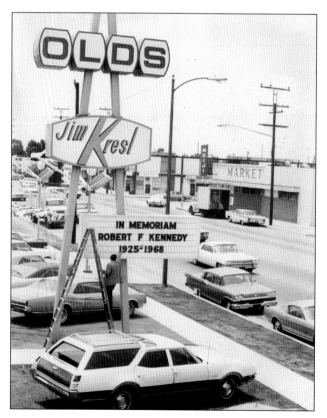

SPECIAL TRIBUTE. When Sen. Robert F. Kennedy was assassinated on June 6, 1968, the bulletin sign at Jim Kresl Olds on Redondo Beach Boulevard was worded in tribute to the fallen presidential candidate. A native of Massachusetts, Kennedy served in the navy during World War II. Starting in January 1961, during his brother's presidential administration, Kennedy served as attorney general. He resigned on September 3, 1964, to become a candidate for the U.S. Senate from New York.

RIBBON CUTTING. Gardena Valley Chamber of Commerce president Walter Klasse presents a plaque to the owners of the new Nordondo cocktail lounge during ribbon-cutting ceremonies. The popular club was located on Redondo Beach Boulevard just west of Normandie Avenue in the late 1960s.

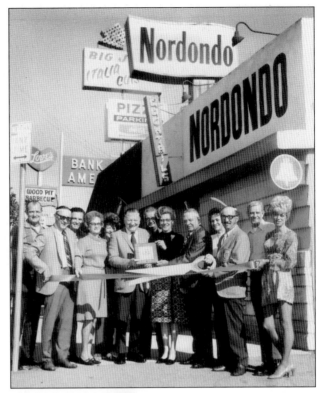

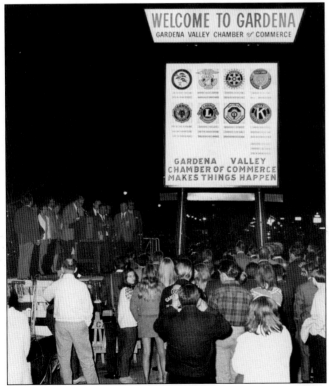

WELCOME SIGN. City officials and members of the Gardena Valley Chamber of Commerce dedicate a "Welcome to Gardena" sign erected on the north side of Redondo Beach Boulevard just east of Crenshaw Boulevard in the late 1960s. The sign was shaped like a Torri Gate in recognition of Gardena's large Asian population. Speaking is chamber president L. W. Umphrey, a local chiropractor.

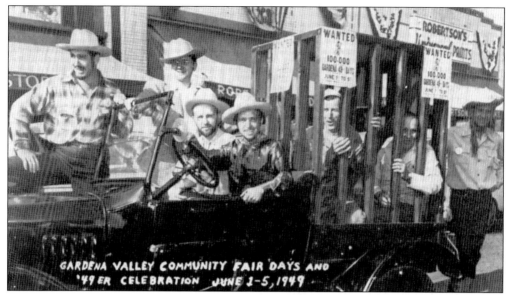

49ER DAYS. Community leaders participate in the annual Gardena Valley Community Days event in 1949.

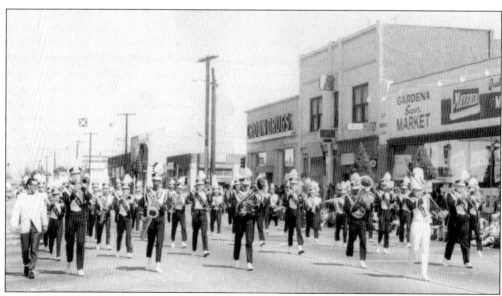

LOYALTY DAY PARADE. For two decades, in the 1950s and 1960s, Gardena had a Loyalty Day Parade to counteract the Soviet Union's May Day celebration. The event was attended by thousands and was televised throughout Southern California. The Gardena High School band is pictured marching down Gardena Boulevard just west of Vermont Avenue.

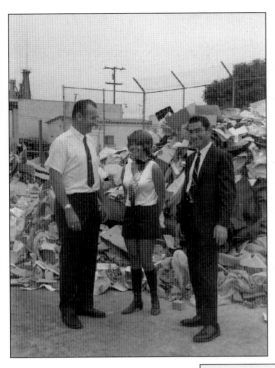

REFUSE-TRANSFER STATION. Founders of Action Transfer Center, located at Brighton and Rosecrans Avenues, pose with Miss Dump. Pictured from left to right are owner Dick Young, Cheri Nazaruk, and owner George Heboian.

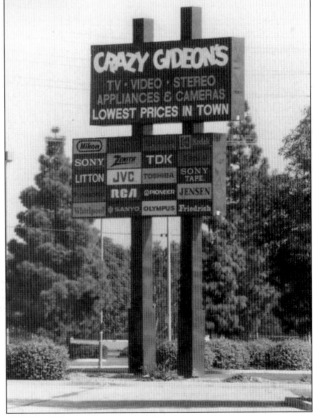

STARTED IN GARDENA. Crazy Gideon's, a famous Los Angeles discount store owned by Gideon Katzer, first began operation in Gardena in 1970. At the time, the store was located in the Cal-Fed building in the 13900 block of Western Avenue, where the city's new transportation department would soon be located.

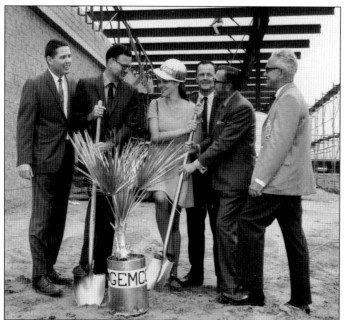

GROUND-BREAKING. Mayor Edmond Russ and Evelyn Brandt—Miss Gardena—with shovels in hand, take part in groundbreaking ceremonies during construction of a GEMCO membership store, located on the site of the old ABC Nursery at the corner of Van Ness Avenue and Redondo Beach Boulevard. When the store opened, membership cost $1, and the money raised was used to support local charities. Target has since taken over the store and is one of Gardena's busiest businesses and supporters of the community.

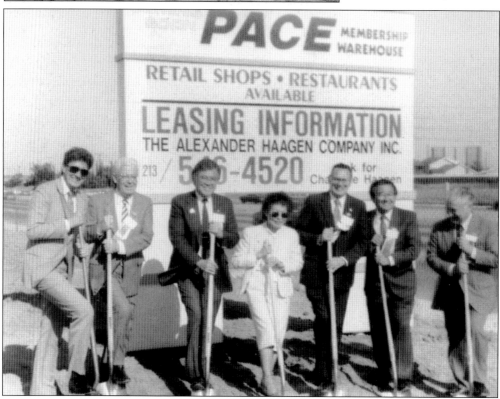

PACE MEMBERSHIP WAREHOUSE. City officials break ground for a PACE Membership Warehouse, located at the northeast corner of Artesia Boulevard and Normandie Avenue. Pictured here, from left to right, are commissioner William Gerber, councilmen James Cragin and Paul Tsukahara, city clerk May Doi, Mayor Donald Dear, councilman Mas Fukai, and contractor Alexander Haagen.

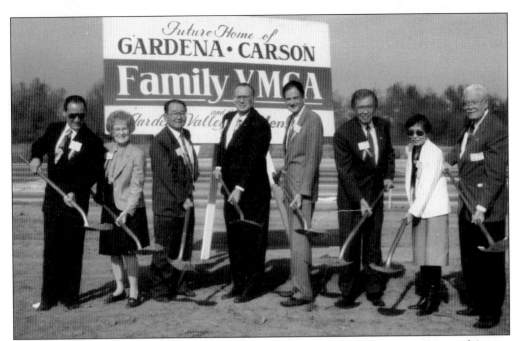

FUTURE HOME. City officials break ground at the southwest corner of Vermont Avenue and Artesia Boulevard for the future home of the Gardena-Carson Family YMCA in the early 1990s. Pictured from left to right, are city treasurer Larry Ybarra, councilwoman Gwen Duffy, councilman Mas Fukai, Mayor Donald Dear, Mayor Emeritus Edmond Russ (who led the fund-raising drive to build the new YMCA), councilman Paul Tsukahara, city clerk May Doi, and councilman James Cragin.

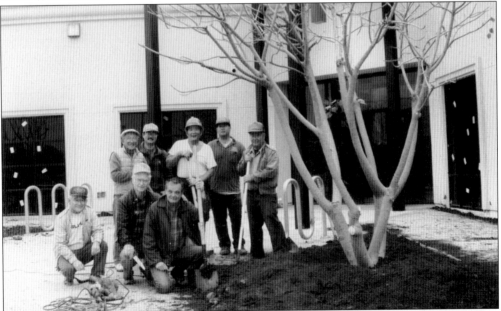

FINISHING TOUCHES. Members of the Gardena Valley Gardeners Association did the landscape work around the new Gardena-Carson Family YMCA, located at 1000 West Artesia Boulevard. Among the workers are Y's Men's Club member Robert Young, Kuni Tamura (past association president), and Gardena Wall of Fame honoree Ryo Komae.

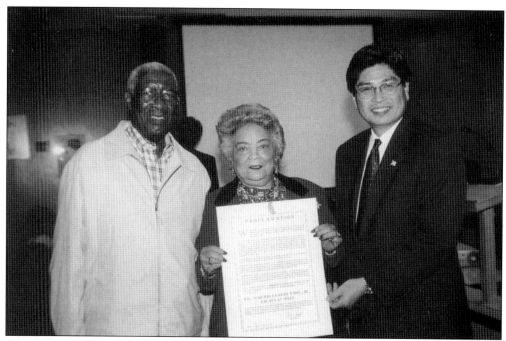

CELEBRATING DR. MARTIN LUTHER KING JR. Mayor Terrence Terauchi presents Arthur Johnson, Dr. Martin Luther King Jr. Committee founder, and committee chair LaVerne Knight with a proclamation in commemorating the 16th anniversary of the Dr. Martin Luther King Jr. Parade and 28th annual celebration. Gardena was the first city west of the Mississippi to celebrate the life and legacy of Dr. Martin Luther King Jr.

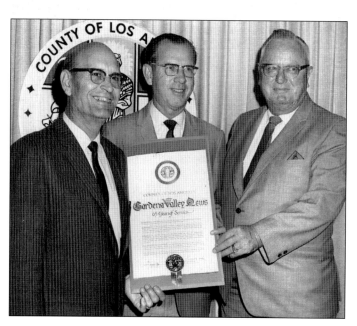

COUNTY COMMENDATION. Los Angeles County supervisor Kenneth Hahn, center, presents a proclamation in commemoration of the 65th anniversary of the *Gardena Valley News and Tribune*. Accepting the commendation are the newspapers copublishers G. Don Algie (left) and William "Bill" Hunt (right). One of the longest-running hometown newspapers in the country, the *Gardena Valley News* started publishing in 1904 and is still going strong well into the 21st century.

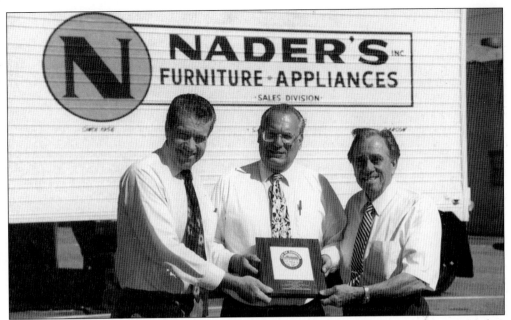

ANNIVERSARY RECOGNITION. In May 1996, the City of Gardena paid recognition to Nader's Furniture on its 40th anniversary. Showing off the plaque, from left right, are Chuck Nader Jr., Mayor Donald Dear, and former city councilman Charles "Chuck" Nader Sr. A street off Marine Avenue, a couple of blocks west of Van Ness Avenue, is named Nader Place in memory of the former city councilman.

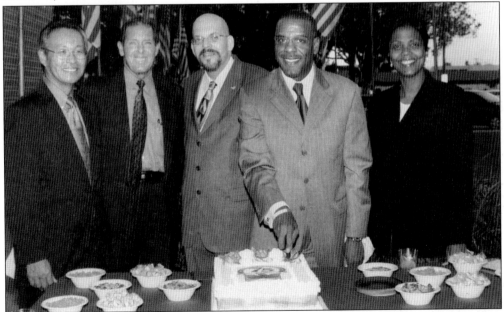

DIAMOND ANNIVERSARY. Celebrating the occasion of the city's 75th anniversary of incorporation are, from left to right, councilman Ronald Ikejiri, city manager Mitchell Lansdell, councilman Oscar Medrano Jr., mayor pro tem Steven Bradford, and councilwoman Rachel Johnson. The City of Gardena was incorporated on September 11, 1930. Bradford has the distinction of being the first African American, and Medrano the first Hispanic, ever elected to Gardena's city council.

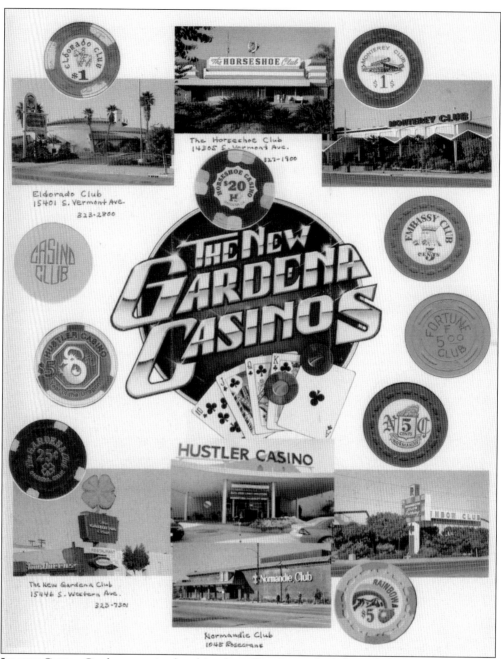

IN THE CHIPS. Gardena was in the chips, literally, when it had the only legalized poker clubs in Los Angeles County. The first club was the Western Club. Others that followed included the Embassy Club, the Fortune Club, the Casino Club, the Gardena Club, the Monterey Club, the Rainbow Club, the Horseshoe Club, the El Dorado Club, the Normandie Club, and the Hustler Casino. Today Gardena has the distinction of having the oldest club (Normandie Club) and the newest club (Hustler Casino) in Los Angeles County.

Three

CARDS, CARS, AND STARS

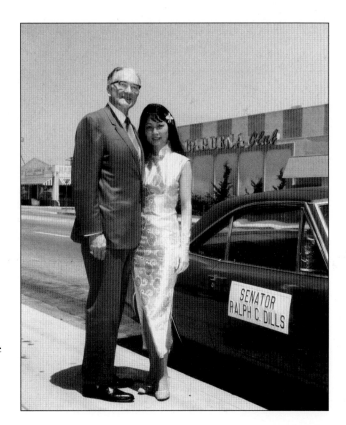

PROMINENT VISITOR. Sen. Ralph C. Dills visits with Eagle Restaurant owner Susie Hom. The two are seen in front of the restaurant that was located in the 15400 block of Western Avenue across the street from the Gardena Club in the late 1960s. Dills was born in Texas and raised in Gardena. He was first elected to the California State Assembly in 1936 and retired from his California State Senate seat in November 1998. He holds the record for having the longest legislative career of any California lawmaker.

CARD CLUB FOUNDER. Russell Miller was one of the three men who came to Gardena in 1936 to start card clubs, and he founded the Normandie Club. Miller was selected to appear on the Gardena Wall of Fame in 1998.

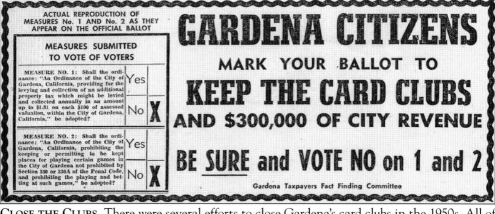

CLOSE THE CLUBS. There were several efforts to close Gardena's card clubs in the 1950s. All of them failed. This advertisement was taken from a pro-card club periodical in 1958.

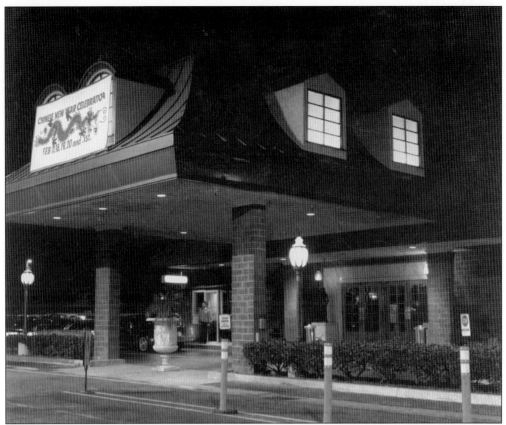

NIGHT VIEW. The Normandie Club is the oldest gambling club in Los Angeles County. The casino moved from Western Avenue to Rosecrans Avenue in the 1970s. This night view depicts the front of the casino now located at 1045 West Rosecrans Avenue. The casino is owned and operated by the Russell Miller family and has been a family-owned operation since its inception in 1940.

CASINO CONSTRUCTION. The El Dorado Club, owned by George Anthony, was erected on the site of the old Embassy Room at the southwest corner of Vermont Avenue and Redondo Beach Boulevard. The club was torn down in the late 1990s to make room for the Hustler Casino, owned by publisher Larry Flynt.

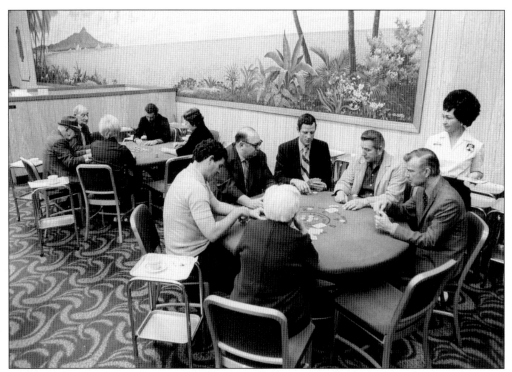

GARDENA CLUB. This inside view of the Gardena Club was taken for an article in *Westways* magazine, which was published by the Automobile Club of Southern California in the early 1970s.

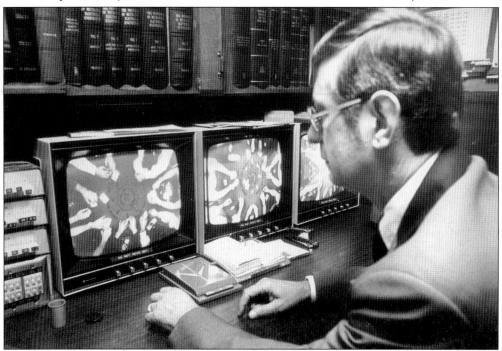

CARD CLUB SECURITY. To prevent cheating or theft by patrons at the Gardena Club casino, all gambling tables at the club were monitored. Pictured is the club's assistant manager, Eddie Cieslinski.

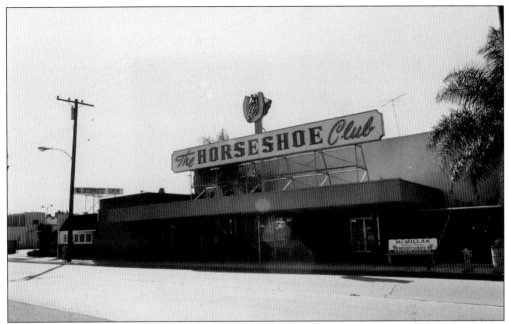

HORSESHOE CLUB. The Horseshoe Club, located at the southwest corner of Rosecrans and Vermont Avenues, was one of two clubs owned by the Bow Herbert Organization. The other was the Gardena Club, located in the 15400 block of Western Avenue.

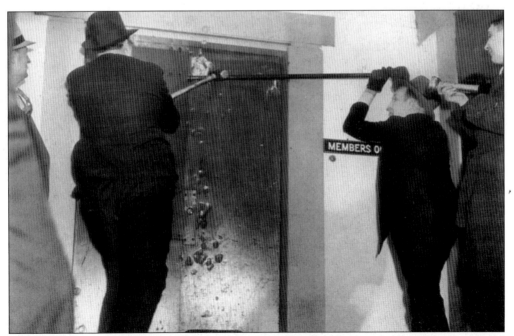

GAMBLING RAID. In the 1930s, illegal gambling was prevalent. Most gambling centers included high fences to screen activities from the street and were also well armed. Pictured here is a raid at a gambling center at 182nd Street and Western Avenue.

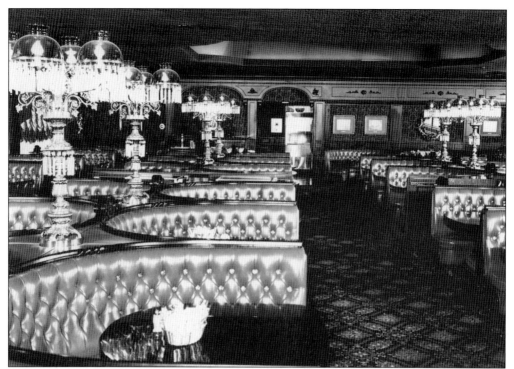

ORNATE INTERIOR. The Monterey Club casino, in the 14000 block of Vermont Avenue, had one of the most beautiful interiors of all of Gardena's popular gambling palaces. It and the Rainbow Club were owned and operated by Ernie Primm, who first brought gambling to Gardena in the mid-1930s. The Primm family would eventually own a number of gambling places at the California/Nevada state line (now known as Primm, Nevada) and in the gambling meccas of Las Vegas and Reno.

NO POT OF GOLD. There was no pot of gold at the end of the Rainbow Club's heyday in Gardena. Workers were locked out and had to wait to be paid after the casino closed its doors in 1983.

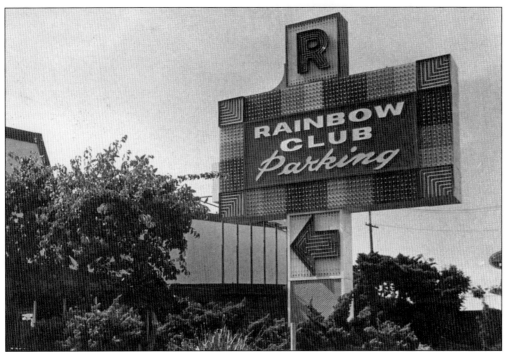

Parking Sign. This is the parking sign at the Rainbow Club casino in the 14000 block of Vermont Avenue in its heyday.

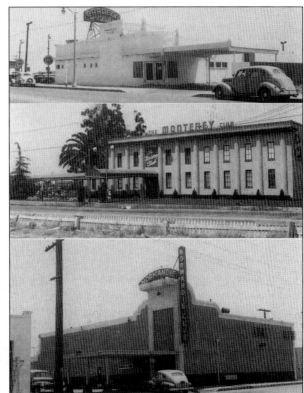

Casinos. A loophole in a 1938 law prompted the establishment of legal-draw poker clubs outside the Los Angeles city limits. The City of Gardena welcomed the tax revenue, and several clubs flourished. Pictured here are (top) The Gardena Club, (center) The Monterey Club, (bottom) The Normandie Club.

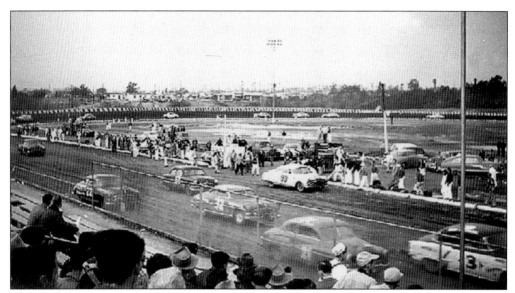

CARRELL SPEEDWAY. Originally built as a half-mile dirt oval race track, Carrell Speedway in Gardena was paved in October 1984. Under the direction of manager J.C. Agajanian, the speedway was the site of foreign-car and big-car races. Agajanian later owned and operated Ascot Park, located on Vermont Avenue near 182nd Street. The speedway was named in memory of Judge Frank Carrell. For many years, Carrell held court on the second floor of a two-story building located on the northwest corner of 166th Street and Western Avenue. The building still stands, and a dance studio has been operating on the second floor of the building for the past 40 years or so.

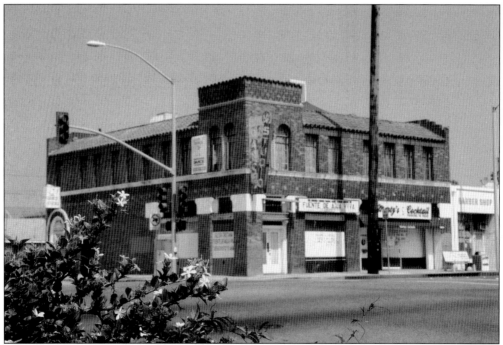

OLD COURTROOM. Judge Frank Carrell held court on the second floor of this building back in the 1940s. The structure still stands at the northwest corner of 166th Street and Western Avenue.

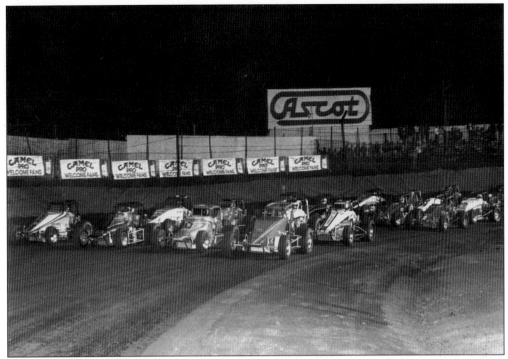

ASCOT PARK. Ascot Park, an oval half-mile dirt racetrack with a motorcycle course in the infield, was located on the corner of 182nd Street and Vermont Avenue. The Thanksgiving Day midget-car "Turkey Night Grand Prix" was a prestigious event on the United States Auto Club calendar. Owned and operated by J. C. Agajanian and his family, Ascot Park hosted many drivers, including Parnelli Jones, A. J. Foyt, Mario Andretti, Rick Mears, Dean Thompson, and Troy Ruttman and was featured regularly on shows, including ABC's *Wide World of Sports*, and on ESPN.

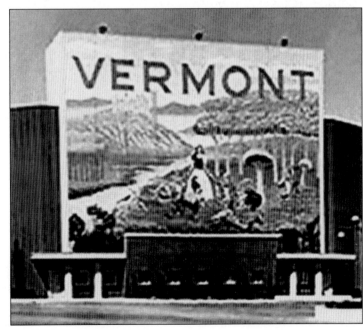

GORGEOUS MURAL. The Vermont Drive-In in Gardena was famous for its impressive entrance and its screen-tower mural of Snow White and the seven dwarfs. It was located on Vermont Avenue, just south of Artesia Boulevard. The drive-in was demolished to make room for a housing development called Emerald Square.

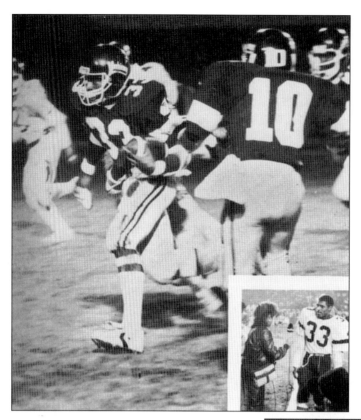

RUNNING BACK. Gardena High School graduate Gaston Green played football for the St. Louis Rams and the Denver Broncos. Green had a good year in 1991, when he was selected to play in the all-pro bowl game in Hawaii.

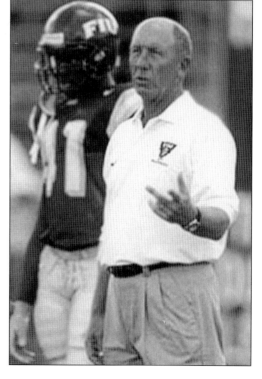

FOOTBALL COACH. Gardena High School's All-American quarterback Greg Briner went on to become a successful football coach. Briner coached at the University of Oregon, Marshall University, the U.S. Naval Academy, the Indianapolis Colts, Southern Methodist University, and Florida International University. He was selected the California Player of the Year while at Gardena High School and was a member of the 1970 Rose Bowl team while attending the University of Southern California.

ALL-AMERICAN. Gardenan Charlie Evans holds the distinction of being Ferris State University's first football player to attain first-team All-America honors. As a running back, Evans led the Bulldogs in rushing three consecutive seasons with 992 yards in 1975 and 1,009 yards in 1977. Evans now lives in Inkster, Michigan, and works in mental-health management for Metro Emergency Services.

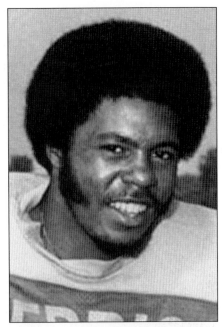

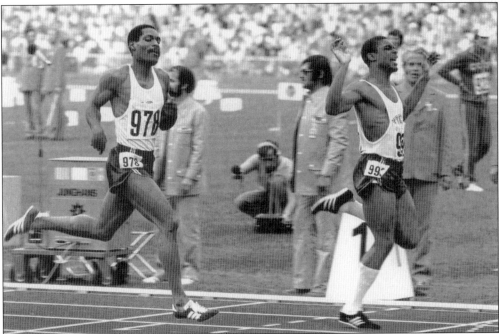

OLYMPIC RUNNER. After leaving Gardena High School, Wayne Collett went on to win a silver medal in the men's 400 meter during the 1972 Olympics in Munich, Germany, on September 7, 1972. Collett became famous for not standing at attention during the playing of the national anthem during his Olympic medal ceremony. He and gold medal winner Vince Matthews stood with hands on hips and talked during the anthem in protest of U.S. civil-rights policies. The protest drew the wrath of the International Olympic Committee, which banned Collett and Matthews from the rest of the Munich games and cost the sprinters a shot at gold as members of the favored 1,600-meter relay team.

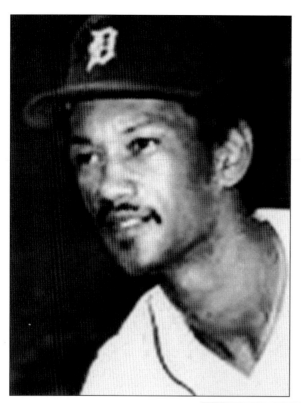

GARDENA BALLPLAYER. Gardenan Enos Cabell was 22 years old when he broke into the big leagues in 1972 with the Baltimore Orioles. Later a deal to Houston gave him his opportunity at third base, a change he took advantage of to become a solid everyday performer. Combining line-drive hitting with speed, Cabell stole over 30 bases every year between 1976 and 1979, having his best year overall in 1977, when he hit .282 with a career high of 16 home runs, 101 runs, and 42 stolen bases. Cabell improved with age, hitting over .300 in 1983 with the Detroit Tigers and again the following season in his second tour of duty with the Astros, this time as a first baseman.

ALL-STAR. Dock Phillip Ellis Jr. is another Gardenan that became a professional baseball player. As a pitcher, his best season was in 1971, when he won 19 games for the World Series champion Pittsburgh Pirates. Ellis has claimed he never pitched a major-league game without the assistance of drugs. He now works as a drug counselor.

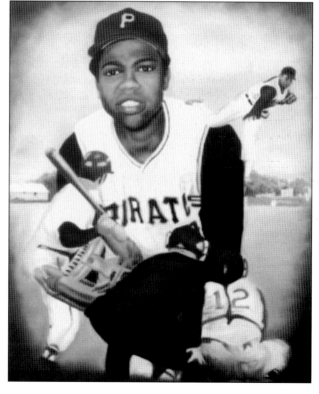

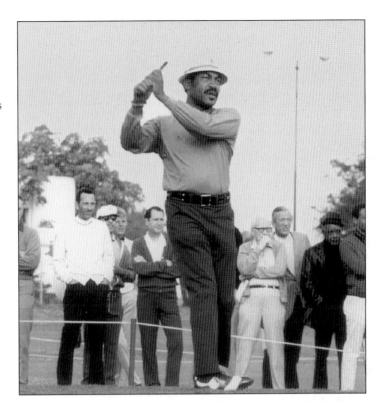

CHAMPION GOLFER. Charles Sifford was the winner of the 1959 Gardena Valley Open Golf Tournament, sponsored by the Kiwanis Club of Gardena Valley. The tournament has been an annual fundraiser for the Kiwanis for over 50 years. Sifford, who became the first African American to receive a law degree from the University of St. Andrews in Scotland, won five straight National Negro Open golf tournaments between 1952 and 1956, the Greater Hartford Open in 1967, the Los Angeles Open in 1969, and the Senior PGA Championship in 1975.

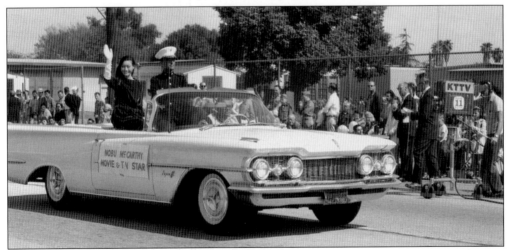

LOYALTY DAY CELEBRITY. Actress Nobu McCarthy appears in a City of Gardena Loyalty Day Parade covered by KTTV Channel 11 television. McCarthy appeared in dozens of motion pictures and television shows, most notably playing the dual-lead role of Jan Wakatsuki and her mother in *Farewell to Manzanar*. Born Nobu Atsumi in Ottawa, Canada, McCarthy grew up in Japan and became a model, winning the title of Miss Tokyo. In 1955, she married U.S. Army Sgt. David McCarthy and moved to the United States. In later years, Nobu was one of the founders of the Asian Pacific American theater company and a strong supporter of the East-West Players. She also taught drama at Cal State University and at UCLA.

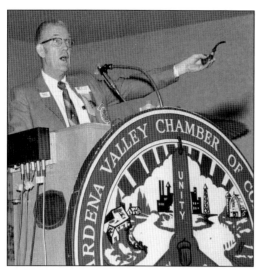

TALENTED ENTERTAINER. Charles David "Bub" Thomas performed at Gardena's Colony Club in the early 1950s before starting his own Roaring Twenties nightclub at 166th Street and Crenshaw Boulevard. He was a talented actor, comedian, ventriloquist, barbershop singer, and artist. Many of his drawings can be seen around Gardena and some of his best decorated the walls of the old Bank Club at 166th Street and Western Avenue. Thomas was an active member of the Gardena Valley Chamber of Commerce and the North Torrance Lions Club. He eventually went to work at Disney World in Orlando, Florida. In 1984, Thomas served as the grand marshal for Donald Duck's 50th Birthday Parade in the Magic Kingdom.

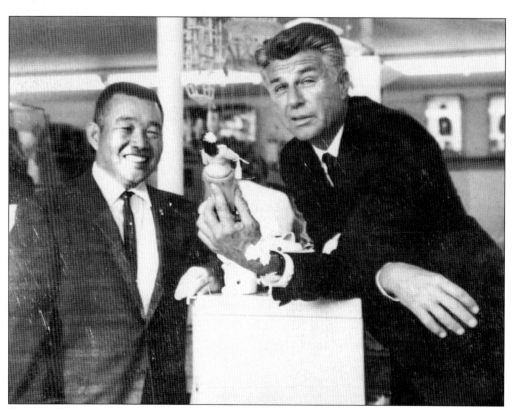

FAMOUS VISITOR. Actor Jim Davis did some shopping at the Nisei Oriental Gift Shop that was owned by Tad Uyemura and located at the Town and Country Shopping Center on Western Avenue. Jim Davis's show-business career began in a circus, where he worked as a tent rigger. He came to Los Angeles as a traveling salesman in 1940 and gradually drifted into the movies after an MGM screen test with Esther Williams. He is probably best known for his work as oil-rich Jock Ewing on the prime-time television series *Dallas*, a role he held from 1978 until his unexpected death following surgery in 1981.

HAPPY BIRTHDAY. For Louis Armstrong's 70th birthday salute at the Shrine Auditorium in 1970, Bow Herbert presented America's goodwill ambassador with a seven-foot cake baked at his Horseshoe Club by the club's award-winning baker, Dick Gee. The Bow Herbert Organization ran the Horseshoe Club and the Gardena Club in Gardena for several decades. They were as well known for their fine restaurants and superb baked goods as they were for their well-attended poker tables. Armstrong holds the toy trumpet that topped the seven-foot birthday cake.

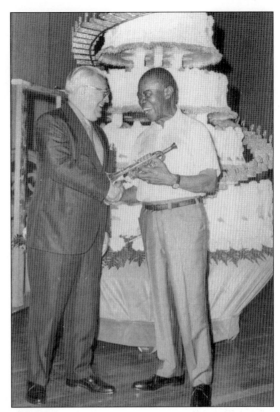

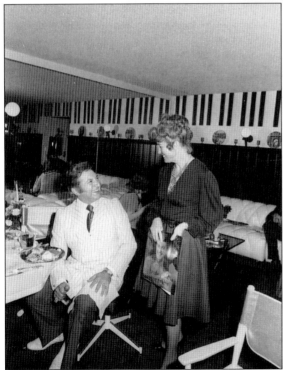

PRESS CONFERENCE. Famed pianist Liberace held a press conference at his home in the Hollywood Hills in 1970 to introduce a new cookbook he had written. He actually prepared the beef stroganoff served to the attending members of the press that day. Here *Gardena Valley News*'s managing editor, Polly Warfield, chats with "Mr. Showmanship." She holds one of Liberace's newest albums and a pair of tickets to a concert he was to perform later that year at the Los Angeles Music Center's Dorothy Chandler Pavilion. (Courtesy of Ken Huthmaker.)

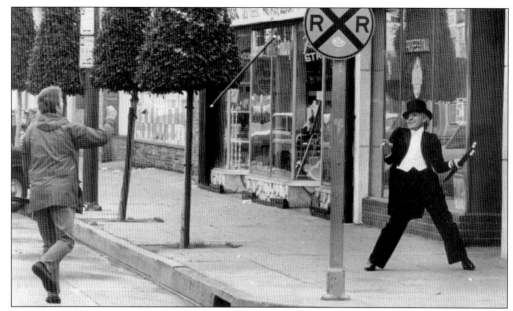

THE JERK. Actor Steve Martin filmed part of his comedy *The Jerk* on the streets of downtown Gardena back in the late 1970s. Here he is at the corner of New Hampshire Avenue and Gardena Boulevard doing a song-and-dance routine. The movie also starred singer/actress Bernadette Peters and was directed by Carl Reiner. *The Jerk* is the story of an imbecile who struggles to make it through life on his own, until a strange invention makes him unbelievably wealthy. Steve Martin got his start in show business performing at the magic shop on Main Street in Disneyland. Aside from being an actor, Martin is also a well-recognized comedian, writer, producer, musician, and composer.

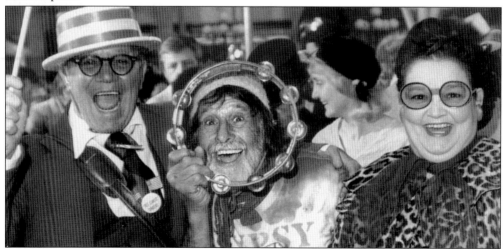

GONG SHOW STARS. For many years, residents Adrian Rosati and his wife, Pat, taught Bel Canto singing at the Gardena Parks and Recreation Department. During the 1970s, they performed on the popular television show *The Gong Show*. Here they are at Grauman's Chinese Theater in Hollywood for the premiere of *The Gong Show Movie*, in which they appeared. They are seen with health guru Gypsy Boots, who is leading the music with his tambourine. Rosati was well recognized around Gardena. He often walked the streets for exercise, shouting out the statement, "What's exciting?" His answer was always the same: "Life."

NISEI WEEK JUDGES. Actors Miko Mayama, Grant Williams, and Edy Williams served as judges of the Gardena Nisei Week contest held in 1970. Mayama starred with Charlton Heston in the *Hawaiians*. Grant Williams appeared in numerous movies, including *Written on the Wind*, and *PT-109*. Edy Williams starred in *Beyond the Valley of the Dolls*, a movie written and produced by her husband Russ Meyer. The winner of the 1970 Miss Nisei Week Gardena contest, Joann Uyemura, went on to become the 1970 Nisei Week Queen, reigning over festivities in downtown Little Tokyo.

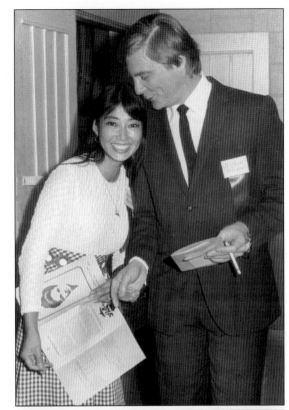

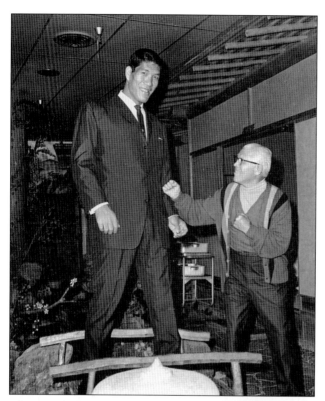

GIANT BABA. Gardena boxer Frankie Garcia pretends to spar with Shohei "Giant" Baba, all six feet, 10 inches, and 330 pounds of him. The photograph was taken at a Japanese restaurant in Little Tokyo where Baba was holding a press conference to promote Japanese professional wrestling. Baba went undefeated as a wrestler for 15 years and was the first and only Japanese three-time National Wrestling Association world-heavyweight champion, nearly single-handedly saving the sport of professional wrestling from extinction in the nation of Japan. Garcia taught boxing at the Gardena Teen Post. In his heyday, Garcia was featured in Ripley's Believe It or Not for having 19 first-round knockouts.

HEAD OF SECURITY. For many years, boxer Sid Marks was the head of security at the Gardena Club. He was featured in a Ripley's Believe It or Not cartoon for training World War II soldiers to fend off bayonets barehanded. A newspaper boy as a kid growing up in England, Marks had a photograph collection of famous celebrities who were former newspaper boys and wrote a book, *The Newspaper Boys' Hall of Fame*. The collection now resides at the Freedoms Foundation in Valley Forge, Pennsylvania.

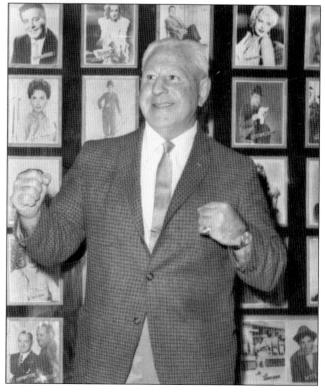

Four

BET YOU DIDN'T KNOW

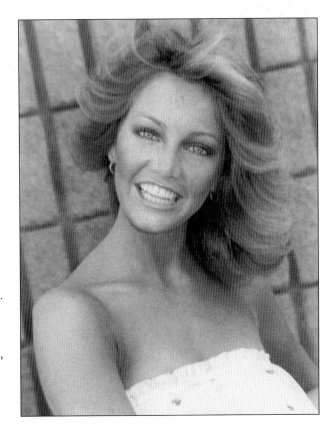

MISS GARDENA PHOTO DAY. The Gardena Camera Club produced the longest continuous series of photo days in Southern California. In 1989, the winner of the Gardena Photo Day was Heather Locklear. She went on to fame and fortune as an actress in numerous television series and made-for-television movie specials. Another actress who got her start as a winner in the 1972 Gardena Photo Day was *Three's Company* star Priscilla Barnes. Bruce Dobos, a Screen Actors Guild member who works as a stand-in for Harrison Ford, got his start at the Gardena Photo Day in 1976.

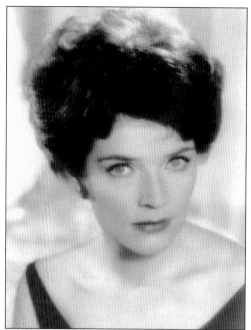

GHS Student. Noted actress and singer Polly Bergen lived in Gardena and attended Gardena High School in the mid-1940s. She became a radio performer at the age of 14, did summer stock, and made night-club appearances en route to Hollywood in 1949, a year after her graduation. She may best be remembered for her role as a housewife in the 1962 movie *Cape Fear* and as Robert Mitchum's wife in the television miniseries *The Winds of War*.

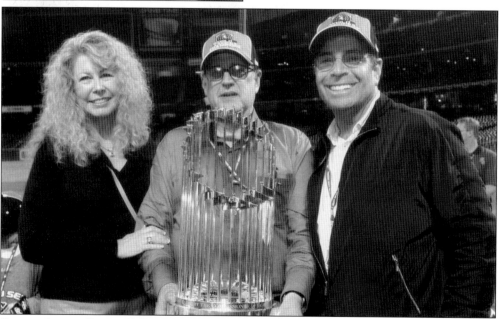

Sports Agent. Dennis Gilbert, a 1965 Gardena High School graduate who participated in track and baseball during his high school years, was a top agent in baseball, representing George Brett, Bret Saberhagen, Danny Tartabull, Jose Canseco, Barry Bonds, Bobby Bonilla, Mike Piazza, and Curt Schilling, among others. Since his retirement in 1999, Gilbert has been a special assistant to White Sox owner Jerry Reinsdorf. Gilbert (right), his wife, Cindi, and Reinsdorf (center) proudly display the White Sox's 2005 World Series trophy. Gilbert, who played minor-league baseball for four years, has a ball field named for him at Los Angeles Southwest College, near Gardena. Though now a resident of Hidden Hills, Gilbert says he has never forgotten the dirt fields of Gardena.

GARDENA NATIVE. American jazz alto saxophonist Arthur Edward Pepper Jr. was born in Gardena on September 1, 1925. He began his musical career in the 1940s playing with Benny Carter and Stan Kenton. In the 1950s, Pepper became one of the leading lights of West Coast jazz along with Chet Baker, Gerry Mulligan Shelly Manne, and others. His autobiography, *Straight Life*, was published in 1980 and is a unique exploration into the jazz world and drug subcultures of mid-20th-century California. Pepper passed away in 1982.

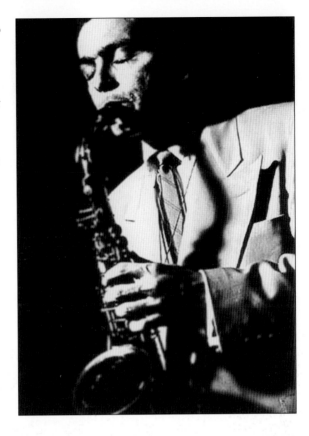

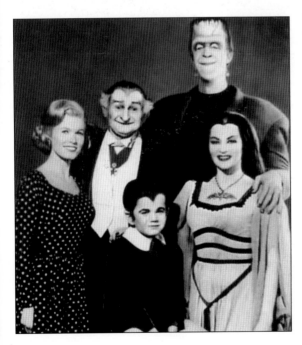

THE MUNSTERS. Actor Butch Patrick was living in Gardena and attending Purche Avenue Elementary School when he was picked out of 26 other boys for a role in the 1961 20th Century Fox movie *The Teddy Bears*, starring Eddie Albert and Jane Wyatt. His father, Dave Lilley, served as the manager of the Monterey Club, and his stepdad, Ken Hunt, played for the New York Yankees and the Washington Senators briefly. Patrick is probably best remembered for his role as Eddie Munster in television sitcom *The Munsters*. He has been in show business now for over 40 years, working with such big-name stars as Burt Lancaster, Judy Garland, Sidney Poitier, Waater Brennan, Audie Murphy, Wayne Newton, Bobby Darin, James Arness, Bill Bixby, and Clint Eastwood.

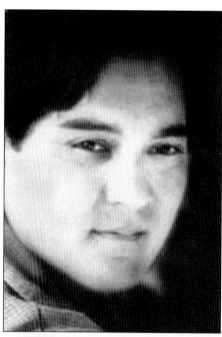

ACTOR/STUNTMAN. Toby Holguin was born in Gardena on December 20, 1969. He has appeared in over 120 movies as an actor, stuntman, or stunt coordinator over the past 30 years. Some of his credits include *Delta Force, Poseidon, Mr. and Mrs. Smith, The Longest Yard, Hidalgo,* and *The Alamo.*

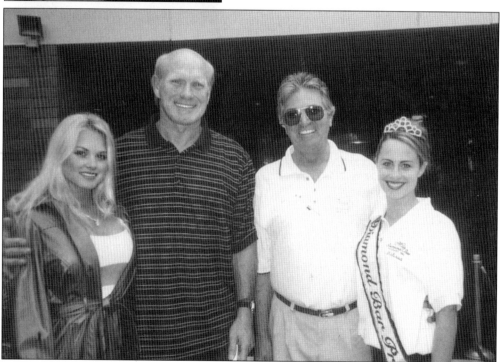

GARDENA RESIDENT. Paul Peterson, an actor with too many credits to mention, is a resident of Gardena who is best remembered as the son on *The Donna Reed Show.* Paul is seen here with Susanne Stokes, Miss Hawaiian Tropic Florida; former Pittsburgh Steelers quarterback Terry Bradshaw, who captured an unprecedented four Super Bowl titles; and a Miss Diamond Bar princess. Peterson runs his organization, A Minor Consideration—which was formed to give support to past, present and future young performers—from his home in Gardena.

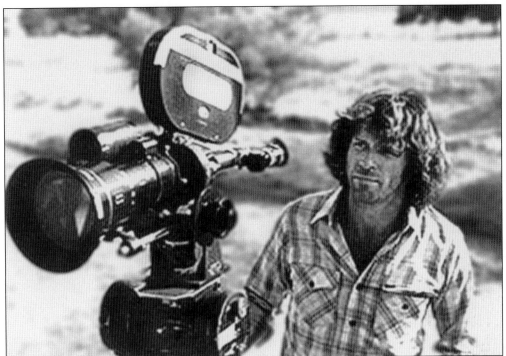

GONE TOO SOON. H. B. "Toby" Halicki was an entrepreneur who owned a dismantling business in Gardena. He is best known for a movie he wrote, produced, and starred in, *Gone in 60 Seconds*, which was loosely based on Halicki's own experiences. The movie was filmed in the South Bay area, mostly in the cities of Gardena, Carson, San Pedro, and Long Beach. The film premiered at the Park Theater in Gardena in 1974. A native of New York, Halicki was killed when a water tower fell on him during a stunt being filmed for a sequel to *Gone in 60 Seconds* in Tonawanda, New York in 1989. Halicki was only 49 years old.

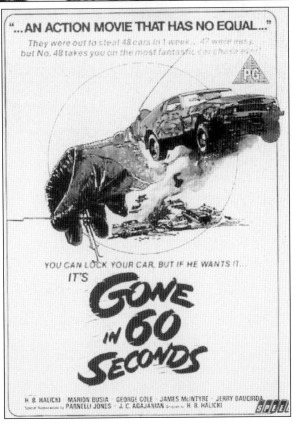

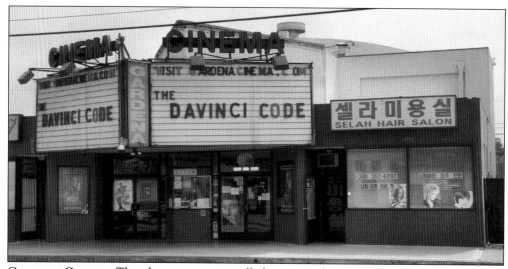

GARDENA CINEMA. This theater was originally known as the Park Theater and was operated by Pacific Theaters. It was a sister house to the Stadium in Torrance with second-run bookings. After the Stadium converted to a Pussycat theater, the Park converted to a Spanish-language house and remained that way for some years. Today, as the 800-seat, family-owned Gardena Cinema, it is one of the few remaining single-screen theaters left in Southern California showing first-run movies.

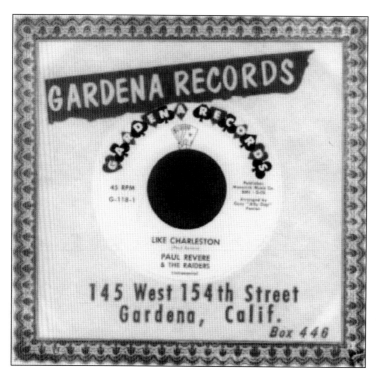

GARDENA RECORDS. A demo tape by The Downbeats caught the attention of John Guss, the owner of Gardena Records, located at 145 West 154th Street. Guss changed the band's name to Paul Revere and the Raiders. Their third release on the Gardena Records label, "Like Long Hair," hit the Top 40 in March 1961 and landed the group on Dick Clark's American Bandstand. The Gardena Records pressing plant also produced 45-rpm records for the Key Brothers, the Altones, and the Craftsmen.

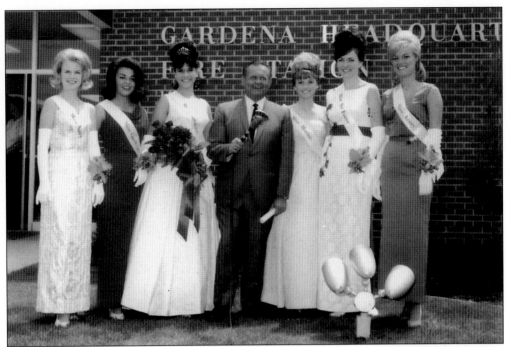

HONORARY MAYOR OF HOLLYWOOD. Johnny Grant, noted actor and master of ceremonies at Hollywood Boulevard Star unveilings, interviewed Miss Gardena contestants for television and served as the master of ceremonies for Gardena Photo Day awards ceremonies in 1972 and 1976. Pictured are the 1965 Miss Gardena and court at the Loyalty Day Parade celebration.

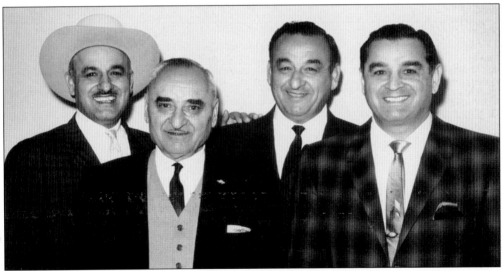

THE AGAJANIAN FAMILY. The prominent Agajanian family was the owner and operator of the Municipal Services Company and Ascot Park in Gardena. Pictured from left to right are J. C. Sr., James T. "Papi" Agajanian, Eli, and Ben Agajanian. Ben Agajanian is known as the first successful kicking specialist in the National Football League. "Bootin'" Ben played for the San Diego Chargers, Oakland Raiders, Green Bay Packers and other teams and earned a 98 percent success rate, scoring 343 out of 351 points after touchdowns.

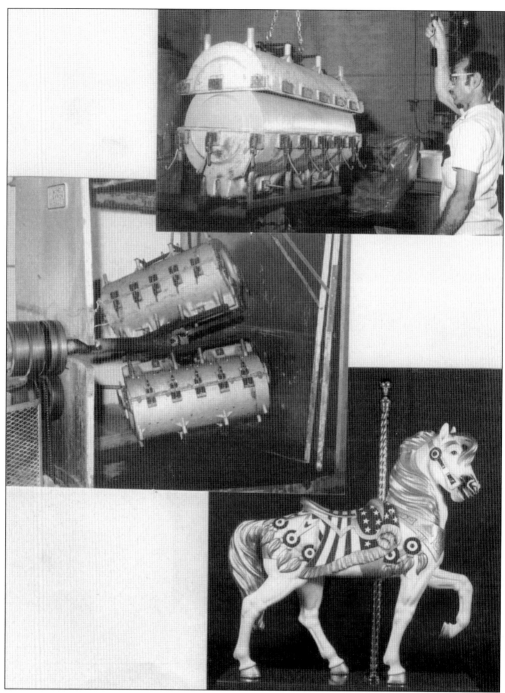

PLASTICS CENTER. Due to the heavy concentration of plastics industries, Gardena is famous as the "plastics center of the world." Some of the plastics companies located in the Gardena area include Rotonics Manufacturing, Inc., Tree-Form Plastics, Inc., Geiger Plastic, Inc., Peerless Injection Molding, Inc., and the Universal Plastic Bag Manufacturing Company. Plastic items coming out of Gardena include everything from bags to flower pots to kayaks and merry-go-round horses. (Courtesy of Rotonics Manufacturing, Inc.)

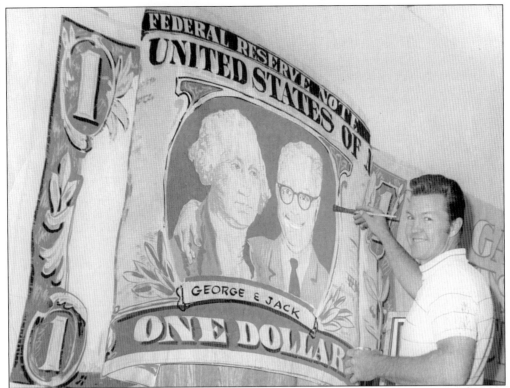

FIREFIGHTING ARTIST. Rassie Harper, a former Gardena firefighter, is well known throughout the South Bay for his outstanding artistic talents. Here he paints a sign for a dinner honoring Gardena's Citizen of the Year Jack Hoel in the late 1960s. Harper served as student body president his senior year at Gardena High School back in 1948.

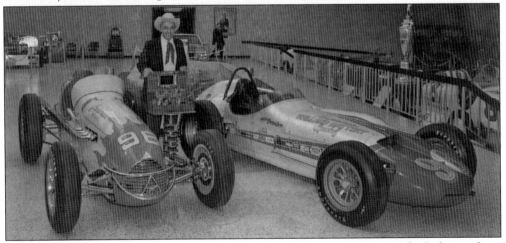

J. C. AGAJANIAN AND THE NO. 98 CARS. J. C. "Aggie" Agajanian poses at the Indianapolis Speedway Museum with his two winning No. 98 cars from the Indianapolis 500. The car on left was driven by Troy Ruttman in 1952, and the car on the right was driven by Parnelli Jones in 1963. The Agajanian family has been represented at the Indy 500 for nearly 50 years now, and "Aggie" has been inducted into the Motorsports Hall of Fame and the National Midget Car Auto Racing Hall of Fame. (Courtesy of The Agajanian Family.)

GARDENA VALLEY OPEN WINNERS

1954 - 1972

1972 - BOB RISCH

1971 - CURTIS SIFFORD
1970 - JERRY HEARD
1969 - JERRY HEARD
1968 - JACK EWING
1967 - HOWIE JOHNSON
1966 - CHARLIE SIFFORD
1965 - PETE BROWN (winning pro)
 BILL MCCORMICK (amateur, tied for first)
1964 - CHARLIE SIFFORD
1963 - JOE KIRKWOOD, Jr.
1962 - GENE ANDREWS (amateur)
 · JOHN LUCAS (overall second, winning pro)

1961 - JIMMY CLARK
1960 - JIMMY CLARK
1959 - CHARLIE SIFFORD
1958 - JERRY BARBER
1957 - TOMMY JACOBS
1956 - SMILEY QUICK
1955 - JIM FERRIER
1954 - BOB DUDEN

A PAGE OF HISTORY. The past winners page of the Gardena Valley Open Golf Tournament includes such legendary names as Charlie Siffort, Jerry Barber, Jerry Heard, Jim Ferrier, and Howie Johnson. In 1954, Gardena City councilman and a professional golfer Harvey Chapman, with fellow PGA professional Earl Martin, brought the idea of hosting an open golf tournament to the Kiwanis Club of Gardena Valley, and the tournament soon began.

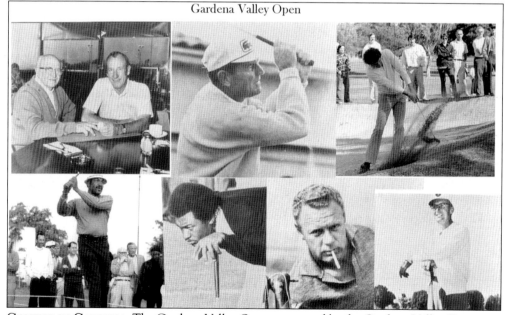

Gardena Valley Open

GOLFING IN GARDENA. The Gardena Valley Open, sponsored by the Gardena Valley Kiwanis Club, was held at Western Avenue Golf Course (now called Chester Washington Golf Course) and was a medal-play competition that eventually grew to a four-day event with a purse of $25,000 by 1973. The tournament is still held each year, but is now an amateur charitable event. (Courtesy of John Nichelson).

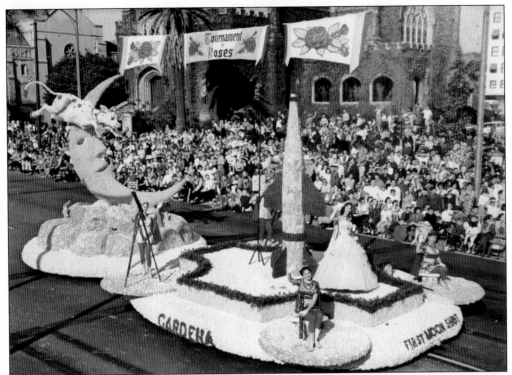

ROSE FLOAT. For a number of years, the City of Gardena entered a float in the world-famous Pasadena Tournament of Roses Parade on New Year's Day. This 1959 entry, "First Moon Shot," was the last float the city would sponsor. Riding the float are Queen Margo Spicer and Princesses Karen Lyons, Sharon Osborn, Jan Parmer, and Carol Perkins. The float cost the city $4,200, a mere pittance compared to floats today, which carry price tags of as much as $100,000 to $200,000.

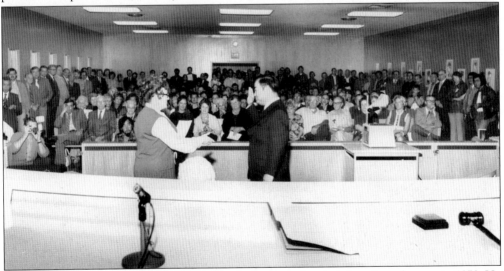

FIRST ELECTED MAYOR. Kiyoto "Ken" Nakaoka became the city's first elected mayor in 1972. He was also the first American of Japanese descent to become the mayor of an American city. The city's community center is named in his honor. Administering the oath of office to Nakaoka on April 18, 1972, is city clerk Doris Diamond Bankus.

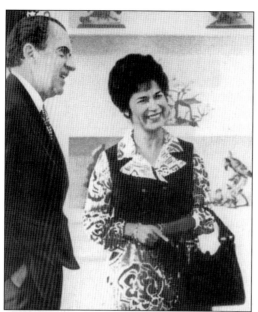

U.S. Treasurer. Romana Acosta Banuelos, the owner of Romana's Mexican Food Products in Gardena, was appointed by Pres. Richard M. Nixon to serve as the treasurer of the United States from 1971 to 1974. She was the first Mexican-American to hold such a high government post. As treasurer, Banuelos's signature appeared on all paper currency. Her responsibilities included writing checks for funds spent by government agencies and destroying worn-out currency. She was born in Miami, Arizona, and grew up in Mexico in the states of Sonora and Chihuahua. She began her career in 1949 with a small investment in a tortilla stand in Los Angeles. Her business eventually grew into a $5 million food enterprise.

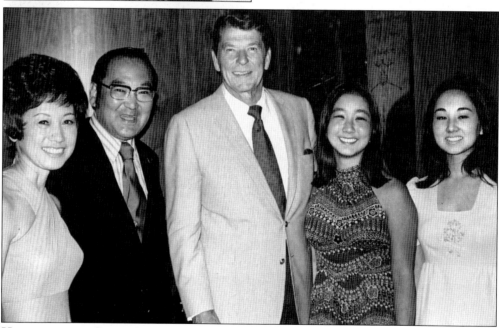

Help from the Governor. Gov. Ronald Reagan helped Gardena City councilman Paul T. Bannai get elected to the California State Assembly during a special election in 1973 to fill a seat left vacant by the untimely death of 67th Assembly District representative Larry Townsend. With Bannai are his wife, Hideko (far left), and daughters Lorraine and Kathryn (left to right). Bannai went on to win election three more times as the state assemblyman from the 53rd Assembly District representing Gardena, Lawndale, Hawthorne, north Carson, and surrounding Los Angeles County. He was the first Japanese-American ever elected to the California state legislature. Later when Reagan became president, he appointed Bannai to the position of chief memorial-affairs director at the Veterans Administration, a post he held from December 7, 1981, until September 30, 1985.

MISS GARDENA. Lorene Yarnell was crowned Miss Gardena/Loyalty Day in 1961. She went on to dance with Bobby Rydell in the movie *Bye, Bye Birdie* and became half of the famed mime team of Shields and Yarnell. Yarnell's court included, from left to right, Renee Harrington (Miss Air Force), Barbara Coleman (Miss Army), Elizabeth Adams (Miss Marine) and Linda Page (Miss Navy). Their military escorts from left to right are U.S. Air Force Sgt. Robert Calbi, U.S. Army Pfc. John Conklin, U.S. Marine Sgt. Sonny Jenkins, and U.S. Navy Storekeeper Second Class Jess Umphenor. Lorene Yarnell's brother Bruce Yarnell had a varied career as a singer in radio, television, stage, and screen. He was the winner of the 1960–1961 season Theatre World Award for his portrayal of General Kinesias in the Broadway musical comedy *The Happiest Girl in the World*. Bruce Yarnell's life was tragically cut short in a plane crash in November 1973. (Courtesy Jess Nevarez.)

NISEI WEEK QUEEN. Gardena's 1970 representative to the Nisei Week Queen contest in downtown Little Tokyo, Joann Uyemura, went on to be chosen the Nisei Week Queen to reign over the Nisei Week Festival that year. Congratulating Uyemura are, from left to right, Gardena Japanese American Citizen League members Joe Fletcher, Fumi Ishino, Toshi Otsu, Helen Kawagoe, and Bruce Kaji.

FIRST STORE. Diana's Mexican Food Products, Inc. started in a small grocery store at the corner of 166th Street and Normandie Avenue in 1969. Hard-working owners, Samuel and Hortensia Magana, along with their three children, Diana, Sam Jr., and Hortensia, have built the business into a prosperous organization. Besides stores and restaurants in Gardena, Norwalk, Carson, El Monte, Huntington Park, and South Gate, Diana's Mexican Food Products can be found in Arizona, Hawaii, Nevada, and Oregon as well as across the Pacific in Japan, where the popularity of authentic Mexican cuisine has skyrocketed.

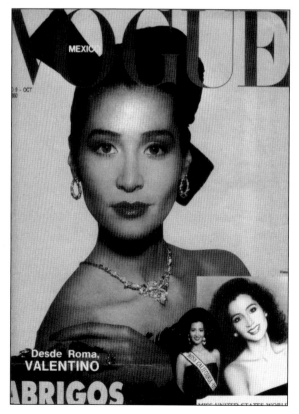

FAMOUS NAMESAKE. Diana's Mexican Food Products, Inc. of Gardena was named for Samuel and Hortensia Magana's first-born daughter, Diana, pictured here. Diana grew up in Gardena, and in 1988, she became the first Hispanic woman to be crowned Miss California U.S.A. A year later, as Miss United States, she competed in the Miss World Pageant in London, England. Magana appeared on the cover of the October 1988 issue of the Mexico edition of *Vogue* magazine.

DAREDEVIL WOMAN. A trip to the Dycer Airfield at 136th Street and Western Avenue in Gardena inspired Katherine Cheung to become the first Asian American woman to earn a pilot's license. The Women of Aviation International Pioneer Hall of Fame and the Museum of Flying in Santa Monica acknowledge her place among aviatrix greats. On her 80th birthday, the Overseas Chinese Historical Society awarded her the title of Woman Dedicated to the Present Age. Because Cheung lived most of her life in Southern California, the Los Angeles Dodgers in 1997 honored her as an inspirational Angeleno at one of its games. In 1991, photographer and activist Carol Nye created a billboard-size image of Cheung to be displayed in Metro Plaza in Chinatown, Los Angeles. The Smithsonian's National Air and Space Museum credits her as the nation's first Asian female pilot. In the Beijing air-force aviation museum, she is honored as "China's Amelia Earhart."

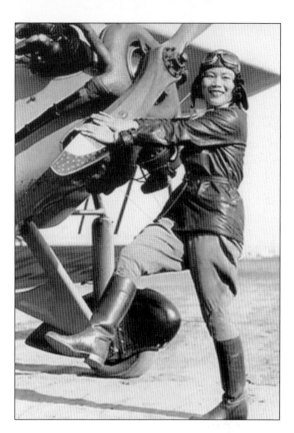

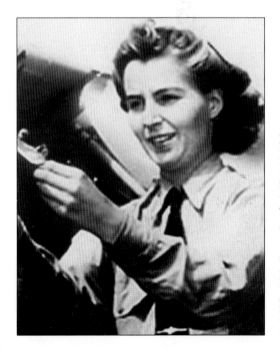

MEMORIAL SCHOLARSHIP. The first Amelia Earhart Memorial Scholarship went to Patricia Thomas Gladney, a 22-year-old flight instructor, on July 3, 1941. Gladney was an instructor in the Civilian Pilot Training Program in Gardena. Her flying career encompassed 50 years as flight instructor; the testing of over 500 private, commercial, and multiengine students as a pilot examiner; 58 years as a Ninety-Nine, the international organization of female pilots; 24 Powder Puff Derbies; and over 20,000 hours flight time. She passed away in 1993.

SENIOR ADVOCATE. Following retirement, Clifford Holliday became an advocate for the betterment of senior citizens in Gardena. A Gardena Wall of Fame honoree, Holliday was the last known surviving Canadian World War I combat veteran. In the summer of 1915, his unit became part of the 16th Infantry Battalion of the Canadian Expeditionary Force in France. He was wounded twice in battle. In recognition of his wartime service, Holliday was awarded France's Legion of Honor and the Canadian McCrae Medallion. Holliday died of natural causes in Gardena at the age of 105.

YOUR FAN. Sally Rand, possibly one of the world's most famous exotic dancers, appeared at the Colony Club in Gardena in the early 1960s. She became famous for her fan dance at the Chicago World's Fair in 1933. Other well-known performers appearing at the Colony Club were all-around entertainment and cartoonist Charles David "Bub" Thomas and vaudevillian Billie Bird. Bird later appeared in the television shows, *Dragnet*, *I Love Lucy*, and *The Loretta Young Show*. Bub Thomas, who once owned his own nightclub, The Roaring 20s, located at 166th Street and Crenshaw Boulevard, later became an entertainer at Disney World in Orlando, Florida. Before it burned down, the Colony Club was one of the most popular burlesque spots in Southern California and was located at 149th Street and Western Avenue. By a strange coincidence, a stripper by the name of Flame was appearing at the Colony Club when fire broke out.

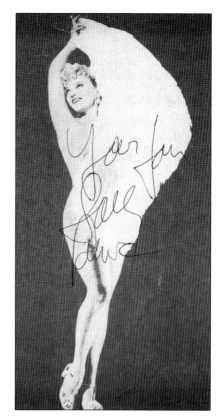

ORIGINAL WNBA PLAYER. Lisa Leslie is a Women's National Basketball Association (WNBA) player currently playing for the Los Angeles Sparks. Leslie was born in Gardena on July 7, 1972. She has won two WNBA championships and also made history by becoming the first player to perform a dunk in this women's professional league.

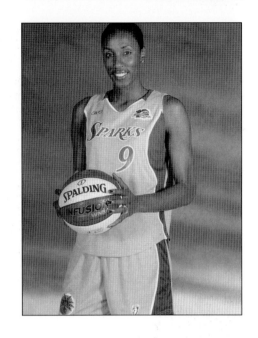

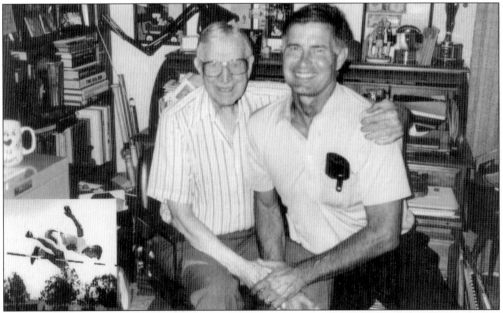

HIGH JUMPER. Pictured here with John Wooden, the "Wizard of Westwood," former UCLA basketball coach, is Gardena resident George Stanich, who won the bronze medal in the high jump at the 1948 Olympic games held in London, England. At UCLA, Stanich became the first Bruin named to the Converse All-America basketball team and was drafted by the Rochester Royals in the second round. Preferring to play baseball and stay closer to home, Stanich, who had also excelled on the diamond at UCLA, joined the Oaks in 1950 and stayed with the Pacific Coast League for five years. Later, until his retirement, Stanich served as a successful basketball coach and teacher at El Camino College, located within walking distance from his home in Gardena.

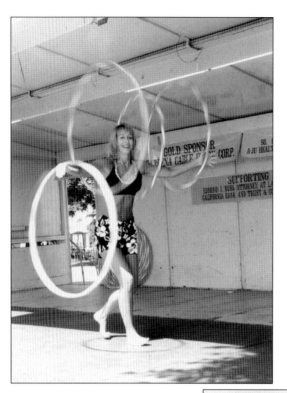

RECORD HOLDER. Champion hula hoop expert Lori Lynn Lomeli is seen performing her artistry at the Gardena Heritage Festival. She and her husband, Carlo, are the owners of Lomeli's Italian Restaurant in Gardena and are strong community supporters. Lomeli has been spinning hula hoops for nearly 40 years and has set two world records. She was just 15 years old when she beat out three million others in a worldwide competition that led to her first Guinness spot for spinning 15 hoops simultaneously. In 1999, she made the Guinness Book of World Records again for spinning 82 hula hoops simultaneously. Now, at the age of 47, Lomeli is hoping to set a new record for the most tricks performed with a hula hoop; she currently can do 100.

STAR AT ASCOT. Robert "Evel" Knievel became a star at Gardena's Ascot Park when he successfully jumped over 16 cars with his motorcycle on May 30, 1967, just 15 months after starting his daredevil career at the National Date Festival in Indio, California. Knievel wears a special ring of which there are only two in the world. He presented the other one to his longtime friend, J. C. Agajanian, owner of Ascot Park racetrack in Gardena.

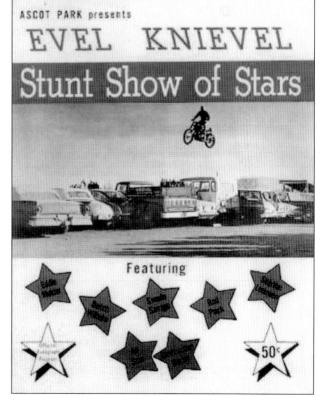

MISS GARDENA JUDGES. Actresses Jayne Mansfield and Greta Thyssen served as judges of the Miss Gardena/Loyalty Day Pageant in the early 1960s. Mansfield was also chosen as queen of the eighth annual Gardena Valley Open golf tournament, held at the Western Avenue Golf Course in November 1961. She is seen above with her husband, Mr. Universe Mickey Hargitay, exercising in the backyard of their Beverly Hills home. Thyssen is seen below backstage during a fashion show held at the Beverly Hilton Hotel. She starred in the stage production of *Pajama Tops* and is a former Miss Denmark who doubled for Marilyn Monroe in the movie *Bus Stop*. (Courtesy of Ken Huthmaker.)

STAR ATHLETE. Longtime Gardena contractor and planning commissioner George Inouye was a star basketball and baseball player during his years at Gardena High School and later as an architectural student at El Camino College in the mid to late 1940s. Inouye's family settled in Gardena after returning home from Poston Relocation Center in Arizona after World War II. As a contractor, Inouye was responsible for the development of Pacific Square, Strawberry Square, the Gardena Valley Baptist Church, and the Town and Country Shopping Center. Inouye was named to the Gardena Wall of Fame in 2006, just a few months prior to his passing at the age of 76.

THE FIRST. On June 23, 1979, the Gardena Farmers Market became the first farmers market to open in Southern California. It is still going strong and is held on Saturdays in the parking lot at the Hollypark United Methodist Church, in the 13000 block of Van Ness Avenue. Since then, a second farmers market has opened in Gardena. It is held on Wednesdays in the parking lot at the Nakaoka Community Center, at 1670 West 162nd Street.

Five

AN "ALL AMERICA" CITY

ONE OF MANY PROGRAMS. Ballet is just one of dozens of classes offered by the Department of Recreation and Human Services. This photograph was taken of a ballet class held at the old civic center in the early 1960s.

ANNUAL TRADITION. Christmas-tree decorating by the staff in the lobby at city hall is a tradition in Gardena. This photograph was taken in 1967 for the *Gardena Valley News*. Pictured from left to right are Jan Greco, Lia Gamez, Nell Bacon, Betty Bunker, Barbara Allen, Marian Vuurman, and Doris Diamond. Greco began working for the City of Gardena in the print shop and of this printing is still working for the city in the position of personnel-office administrative assistant.

DODGER DAY. Los Angeles Dodger manager Tommy Lasorda greets attendees from Gardena during Gardena Dodger Day in 1987. Pictured with Lasorda from left to right are insurance-business owner Randy Doerschel, recreation-services manager Kathy Walker, *Gardena Valley News* columnist Tom Parks, and administrative assistant Jim Gregg.

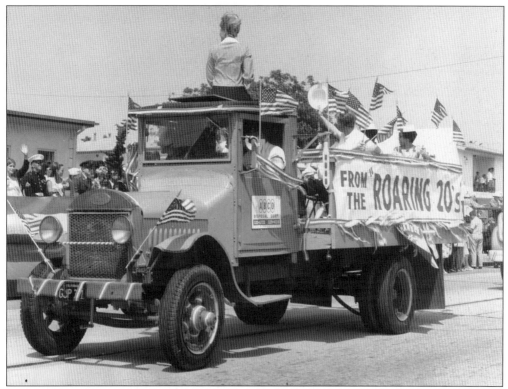

LOYALTY DAY FLOAT. This is an ABCO disposal truck with a banner "From the Roaring 20s" as it appeared in one of the early Gardena Loyalty Day Parades. The Roaring 20s was a popular nightclub owned and operated by entertainer Bub Thomas at the corner of 166th Street and Crenshaw Boulevard.

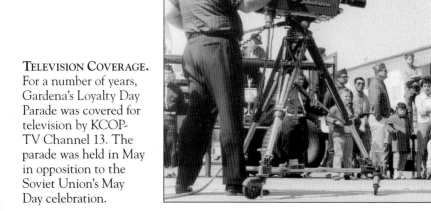

TELEVISION COVERAGE. For a number of years, Gardena's Loyalty Day Parade was covered for television by KCOP-TV Channel 13. The parade was held in May in opposition to the Soviet Union's May Day celebration.

MLK PARADE. Gardena was the first city west of the Mississippi to honor the memory of Dr. Martin Luther King Jr. Every January, close to King's birthday, the city holds the MLK parade and celebration. Here the Gardena High School band and drill team line up for the parade that runs down Van Ness Avenue between Marine Avenue and Rowley Park.

NEW STAMP. The Paul Robeson commemorative stamp is unveiled at the city's Black History Month Trailblazer Program by Gardena postmaster Cheryl Gardener and city councilman Steven Bradford. The Trailblazer Program is one of the city's efforts to bring heightened awareness of African American history to the culturally diverse Gardena community.

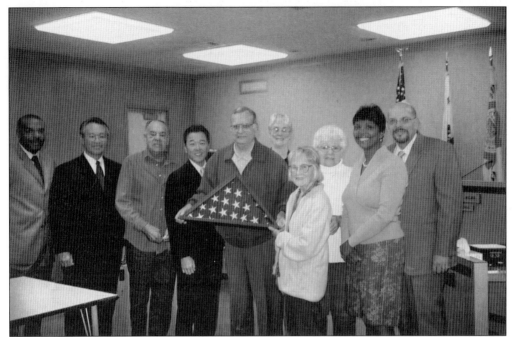

FLAG DAY. Gardena Beautiful Committee Flag Day chair and Gardena Wall of Fame founder Gene Dedeaux promotes a Flag Day Program during a city-council meeting. With him are councilmen Steven Bradford and Ron Ikejiri, Beautiful Committee member Bill Lebeaud, Mayor Paul Tanaka, Beautiful Committee members Loyce Holt, councilwoman emeritus Gwen Duffy, and Joan Quintana, councilwoman Rachel Johnson, and councilman Oscar Medrano Jr.

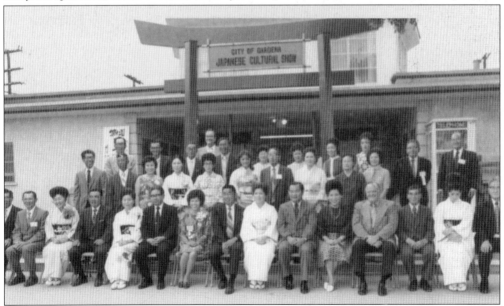

JAPANESE CULTURAL SHOW. For over two decades, the Gardena Valley Gardener's Association hosted a Japanese cultural show at the Gardena Community Center. It featured miniature trees (bonsai), flower arrangements (Ikebana), Japanese dancing, a tea ceremony, a beautiful Japanese garden, and a huge, red Torii Gate.

ON PARADE. The two soldiers carrying the 20th annual Cinco de Mayo Parade banner had just returned from a tour of duty in Iraq when this parade was held, on April 29, 2006. It traditionally begins at the corner of New Hampshire Avenue and Gardena Boulevard and moves west on Gardena Boulevard to Normandie Avenue before going north to Mas Fukai Park, where a Cinco de Mayo Fiesta is held in celebration of the defeat of 8,000 French and traitor Mexican-army soldiers by 4,000 Mexican freedom fighters at Puebla, Mexico, on May 5, 1862.

JAZZ FESTIVAL. The true essence of jazz is captured at the annual Gardena Jazz Festival, held at Rowley Park in August. Jazz enthusiasts kick back under the warm afternoon sun to enjoy an afternoon of outstanding jazz music.

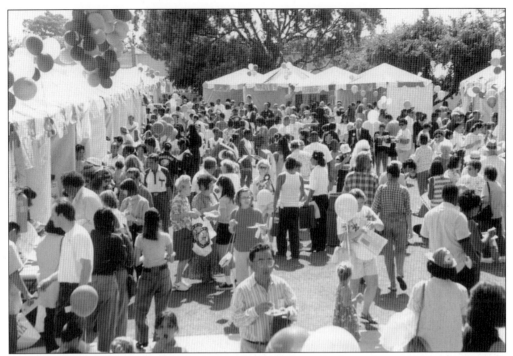

HERITAGE FESTIVAL. Thousands of patrons turn out each year for the city's annual Heritage Festival, held in October on the grounds of the Gardena Civic Center. The festival is a celebration of Gardena's diversity and features displays, information booths, food, fun, and daylong entertainment.

BRIDGE OF FRIENDSHIP. Local children pose on a bridge used as a prop to draw attention to Gardena's annual Heritage Festival.

WAR MEMORIAL. Gold Star mother Mary Ybarra stands in the foreground as Pearl Harbor survivor Frank Schilling salutes the Gardena War Memorial, dedicated on May 29, 1972. The Ybarras lost their son Kenny when he was killed in Vietnam. Kenny's dad, Ted Ybarra, chaired the drive to have the war memorial erected along the Lucille Randolph Memorial Plaza leading to Gardena City Hall. Among the names engraved on the memorial are those of World War II Medal of Honor recipients from Gardena, Harold H. Moon Jr. and Kiyoshi Muranaga.

MEDAL OF VALOR. Workers are seen erecting the Medal of Valor monument located near the Gardena Police Station. The monument honors men and women from the Gardena Police and Fire Departments for service "Beyond the Call of Duty." Honorees are selected each year by South Bay chambers of commerce. Chairing the campaign to raise funds for the monument, dedicated on April 16, 1998, was city councilman Al Defelippo.

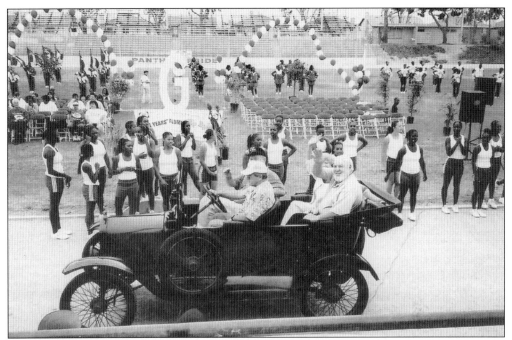

HIGH SCHOOL ANNIVERSARY. Gardena High School celebrated its 100th anniversary in 2004. Among those taking part in a parade on the school's athletic field was former football coach Dick Enright. He and coach Stan Smith led the Mohican football team to several city championships.

MOHICAN CHEERLEADERS. Joyce Uyeda, Candace Fujii, and Linda Lamb lead fans in a cheer during a Gardena High School football game in 1967.

MODEL CITY. Gardena's WeTip (Turn in Pushers) chair Gwen Duffy presents a plaque to city council commending the City of Gardena as the WeTip Model City of the Year for 1995. Gardena is the only city to be so recognized twice. Gardena is a member city of WeTip, a national program that fights crime through anonymous tips on criminal activity. The WeTip committee is chaired by a councilmember and is composed of city staff and school and community leaders working together to increase public awareness and cooperation in reducing crime in the Gardena area. Pictured from left to right are councilman Paul Tsukahara, councilwoman Gwen Duffy, Mayor Donald Dear, and councilman James Cragin.

MUSICAL TRIBUTE. Outstanding singer and Gardena vocal/piano teacher Sue Okabe was honored with a concert given by her students at the Japanese-American Theater in Little Tokyo shortly before her passing in December 2002. Having begun classical training at the age of eight, the young music prodigy traveled the country performing at rotary clubs, war-bond rallies, and USO centers during the war years. As a professional performer, Okabe had the lead role in *A Flower Drum Song*, which was produced by the Long Beach Civic Light Opera Company in 1963.

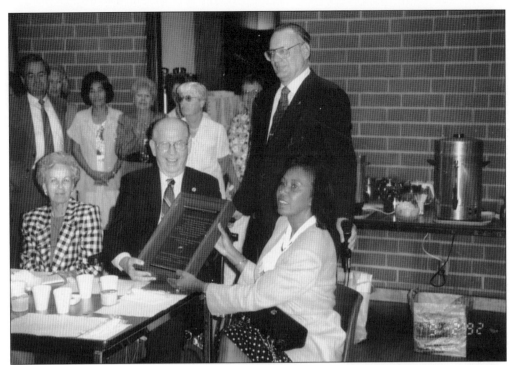

HONORED FOR SERVICE. Kenneth "Kenny" Hahn was honored in Gardena for his 40 years (1952–1992) of service as the supervisor in Los Angeles County District 2. With him are his wife, Ramona, Mayor Donald Dear, and Hahn's successor, supervisor Yvonne Brathwaite-Burke.

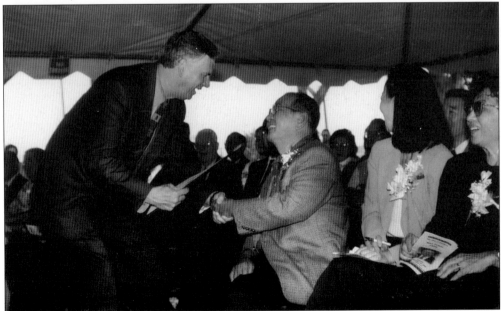

PARK DEDICATION. Los Angeles mayor James K. Hahn pays recognition to Masani "Mas" Fukai upon the occasion of the renaming of Recreation Park in Fukai's honor. Fukai served for many years as a Gardena city councilman and as the chief deputy to Hahn's father, supervisor Kenneth "Kenny" Hahn. With Fukai are his daughter Janice and wife, Yuriko.

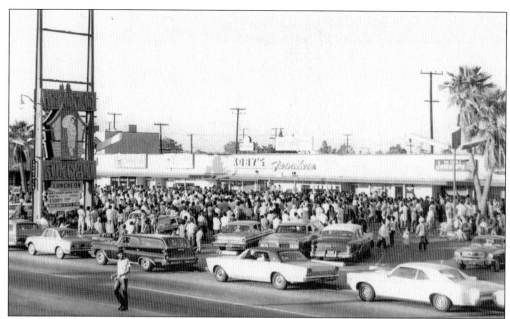

ANNIVERSARY CELEBRATION. Crowds gather at the Town and Country Shopping Center for an anniversary celebration in the late 1960s. The center was remodeled in 1983 and was changed to the Kyoto Plaza Shopping Center. Town and Country was known as the home of the Kyoto Sukiyaki Restaurant as well as of Spot Market, Koby's Appliances, and the Nisei Oriental Gift Shop. Those places are gone now, but the memories linger.

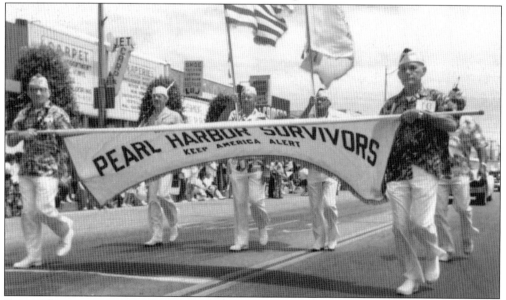

PEARL HARBOR SURVIVORS. The 11 founding members of the Pearl Harbor Survivors Association (PHSA) held their first reunion at the VFW Rosecrans Post No. 3261 in Gardena on December 7, 1958. The founding members included George W. Haines Jr., Sam Kronberger, Raymond J. Le Ber, Mark Ferris, James C. Taneyhill, Clarence E. Bonn, Ed Kronberger, Robert S. Kronberger, Ed Steffa, George Schaffer, and Lewis P. Smith. Today PHSA has 38 state chapters and surviving members in every state.

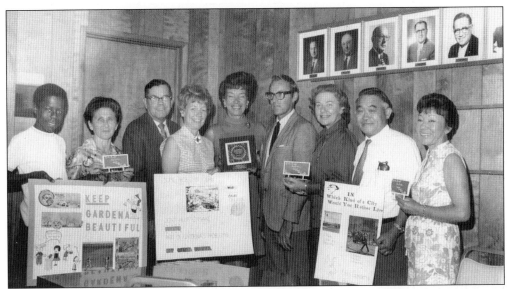

PROMOTING BEAUTY. Gardena Valley Chamber of Commerce leaders display posters promoting the beautification of Gardena in the late 1960s. On the left is Leo Terrell, then a student body president at Gardena High School, who would serve several decades later as the grand marshal at Gardena's Dr. Martin Luther King Jr. parade and celebration. He is well known throughout the southland as the "fair-minded civil-rights attorney" with a program Sunday nights on KABC 790 AM talk radio.

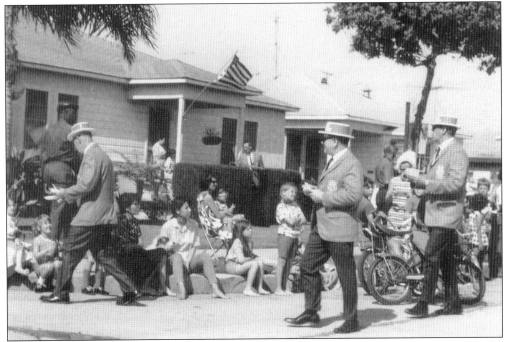

AMBASSADORS. Chamber ambassadors are pictured here doing some door-to-door promotions for the Gardena Valley Chamber of Commerce. In the middle is chamber ambassador Walter Klasse. His life ended tragically when a robber shot and killed him while he and his wife were visiting their daughter in Gardena many years later.

CHAMBER INSTALLATION. Dr. L. W. Umphrey, second from left, is seen on the night of his installation as president of the Gardena Valley Chamber of Commerce. Congratulating him from left to right are assemblyman Larry Townsend, Sen. Ralph Dills, and Mayor Edmond Russ.

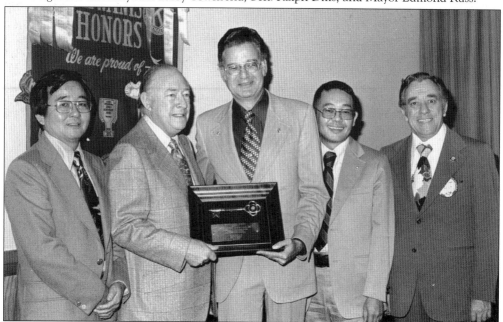

KEY TO THE CITY. Congressman Charles Wilson receives a key to the city from Mayor Edmond Russ during a dinner in Wilson's honor sponsored by the Kiwanis Club of Gardena Valley. Pictured from left to right are councilman Mas Fukai, Charles Wilson, Edmond Russ, and councilmen Don Hata and Chuck Nader.

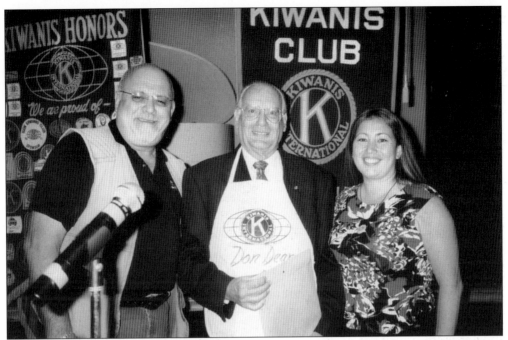

INDUCTION. This is Gardena's longest serving mayor, Donald Dear (center), the day he was inducted into the Kiwanis Club of Gardena Valley by district governor Ernie Urban and club president Kelly Fujio. Urban and Dear were classmates and 1957 graduates at Gardena High School.

FISHING FOR FUN. Every year the Kiwanis Club of Gardena Valley hosts the South Bay Youth Fishing Event, held at Alondra Park. Other event sponsors include the City of Gardena, the South Bay Lady Anglers, the County of Los Angeles Department of Parks and Recreation, and the California Department of Fish and Game.

OLDEST SERVICE CLUB. The Gardena Valley Lions Club is the oldest service club in Gardena. Here the members of the organization, along with members of the El Camino Lions Club, man their mobile screening unit during the city's Children's Health and Safety Fair, held at the Nakaoka Community Center.

LIONS CLUB HONOREES. The Gardena Valley Lions Club, the oldest service club in Gardena, selected *Gardena Valley News* publisher G. Don Algie (center) and managing editor Gary Kohatsu (left) for their community recognition award during their 24th annual recognition banquet in 2004. Congratulating the honorees is Mayor Terrence Terauchi.

DIRECTORY COVER. The beautiful Japanese garden at the Gardena Mayme Dear Memorial Library was the subject of Pacific Telephone's directory cover in October 1970. A perma-plaque copy of the cover hangs in the library next to the windows through which patrons enjoy the garden, kept alive and beautiful by members of the Gardena Valley Gardener's Association.

WELCOME. Gardena Sister City members Francis Stephen and Kirk Mori welcome a delegation of young ladies from Gardena's sister city of Ichikawa, Japan, in August 1969. The youthful delegates, members of an all-girls high school in Ichikawa, experienced life in Gardena homes, toured government buildings and local businesses, took part in the Gardena Buddhist Church Obon Festival, and enjoyed the Nisei Week Parade and Festival in downtown Little Tokyo. Stephen served for many years as the principal of Peary Middle School.

BELL TOWER. Dedication of the Bell Tower at the Gardena Buddhist Church was held in August 1968. Standing in front of the bell, a gift from Gardena's sister city of Ichikawa, Japan, are, from left to right, Gardena Sister City members Ken Huthmaker, Darlene Oylear, Debbie Kobayashi, Sue Obayashi, Bruce Oylear, Tony Ybarra, Lily Fujikawa, Kirk Mori, Katherine Hammagren, Glenn Hata, and Dr. Tom Mayeda. The bell is gonged on December 31 each year by worshippers after attending the New Year's Eve service, also known as Joya-no-Kane.

ANGELS FLIGHT. In the late 1990s, delegates from Gardena's sister city of Ichikawa, Japan, toured Gardena and Los Angeles, and visited Disneyland. While in Los Angeles, the group had a rare chance to ride on Angels Flight. The "Shortest Railway in the World" first opened in 1901, was dismantled in 1969, and finally was restored a half a block from its original site at Fourth and Hill Streets in 1996. The attraction was temporarily closed following an accident on February 1, 2001, and is scheduled to reopen in late 2006.

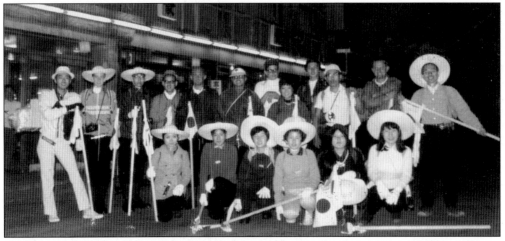

CLIMBING MT. FUJI. Members of the youth delegation to Gardena's sister city of Ichikawa, Japan, pause for a photograph just before beginning their climb up Mount Fuji on Monday, August 24, 1970. Included in the group from Gardena were Debbie Kobayashi, Lily Fujikawa, Kirk Mori, Bruce Oylear, Dean Petro, Glenn Hata, Richard Arias, Ronald Grossman, and coleader Ken Huthmaker. Joining the Gardena delegates were students from Ichikawa's Konodai High School, including Akiko Goto, Atsuko Onishi, Yoshiko Takamori, Kazuko Sato, Mika Oshikawa, Ichikawa city officials Hironobu Murata, Nobuo Kageyama, Takao Inoue, Yasuhisa Oki, and guide (and Konodai High School coach) Shobei Nakajima.

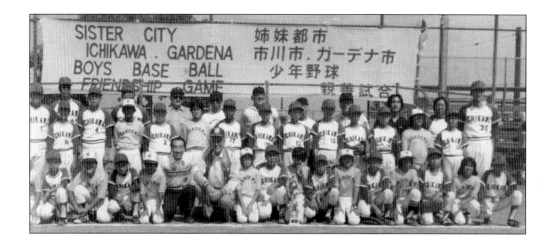

FRIENDSHIP GAMES. Gardena has two sister cities, Ichikawa, Japan, and Huatabampo, Mexico. Baseball games help to solidify friendships between the children of the three cities. The cities also enjoy cultural exchanges and visits of delegates, who have a chance to stay in the homes of the residents of the three cities.

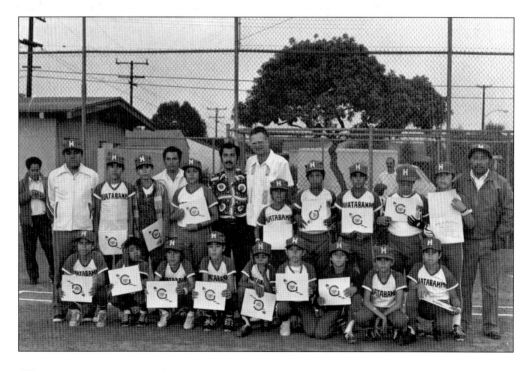

GENEROUS DONATION. Members of the Gardena-Huatabampo Sister City committee pose with a fire truck that the City of Gardena donated to the citizens of Huatabampo, Mexico, in the mid-1990s.

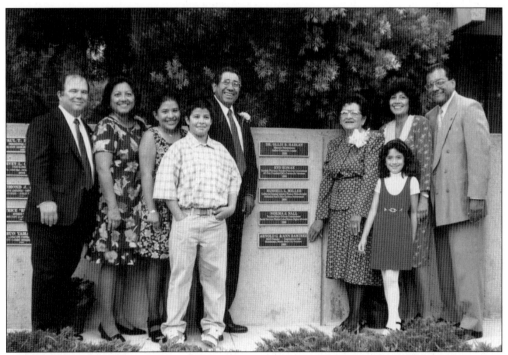

PROMINENT FAMILY. Huatabampo sister-city founders Arnold and Ann Ramirez were named to the Gardena Wall of Fame in 1998. Ann served for many years as an aide to Congressman Glenn Anderson, the former lieutenant governor and youngest mayor in the country when he was the mayor of Hawthorne. Pictured with the honorees are, from left to right, family members Dale, Barbara, Tina and Danny Pierce, Arnold Ramirez, Ann Ramirez, Joann Bolle (front), Judy Sutton (rear), and Tom Ramirez (right).

A SPECIAL PLACE. Huatabampo Place, a street off of Gardena Boulevard just west of Vermont Avenue, was named in honor of Gardena's sister city in Mexico. Holding the street sign during dedication of the street in 2004 are the mayors of Gardena and Huatabampo.

GARDENA AVENUE. Gardena city employees Michelle Enosara (left), Kelly Fujio (center), and Ellen Emerson visit Gardena Avenue and park in Gardena's sister city of Ichikawa, Japan.

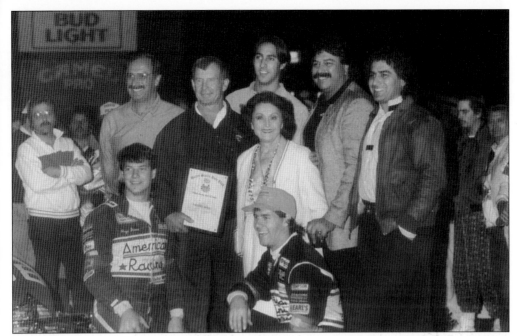

LAST RACE. After 33 years of racing, Ascot Park closed in 1990. The park, which sat 8,000 spectators, was home to two professional tracks, an automobile-racing track and a motorcycle track, plus one slic track for recreational use. In addition to stock and midget cars, Ascot also hosted many races of motocross, the National Dirt Bike Championship, speedway racing, and other types of events on the one-eighth mile American Motorcycle Association stadium. Pictured from left to right are (kneeling) Page Jones and P. J. Jones, (standing) Cary Agajanian, Parnelli Jones, Josh Agajanian, Hazel Fay Agajanian, J. C. Agajanian, and Chris Agajanian.

MEMBERSHIP MARKET. The Marukai Membership Market is located at the southeast corner of Artesia Boulevard and Western Avenue, where a Builders Emporium once stood. The market carries goods made in Japan and is very popular with Gardena's ethnically mixed population.

GARDENA SYNAGOGUE. Southwest Temple Beth Torah was for many years the home to Gardenans of the Jewish faith. Overseeing services at the temple was Joseph Schimmel. Wall of Fame honoree Martha Kawada served as the temple's office manager. Kawada is a sister of Gardena's first elected mayor Kiyoto "Ken" Nakaoka.

WILLOWS WETLANDS. From the observation platform, visitors get a picturesque view of the Willows Wetlands in Gardena. The wetlands are located on the west side of Vermont Avenue just north of Artesia Boulevard. Entrance to the habitat is located in the southeast corner of South Park at 1200 West 170th Street. The Gardena Willows Wetlands Preservation Committee holds monthly cleanups to help maintain, protect, and beautify the 13-plus-acre habitat and to serve as docents during special tours.

BUDDHIST CHURCH. Established in 1926, the Gardena Buddhist Church celebrated its 75th anniversary in 2001. The current building was dedicated on August 21 and 22, 1982. The building, the fifth the church has had since its founding, suffered a series of three arson fires before it was finally completed.

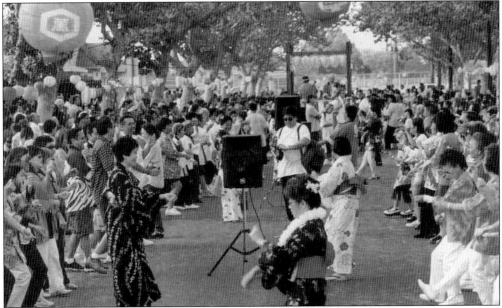

OBON FESTIVAL. Every August the Gardena Buddhist Church celebrates Obon with a festival. Highlighting the festival are two nights of street dancing along Halldale Avenue just north of 166th Street. Obon is an annual Buddhist event for commemorating one's ancestors. It is believed that each year during Obon, the ancestors' spirits return to this world in order to visit their relatives.

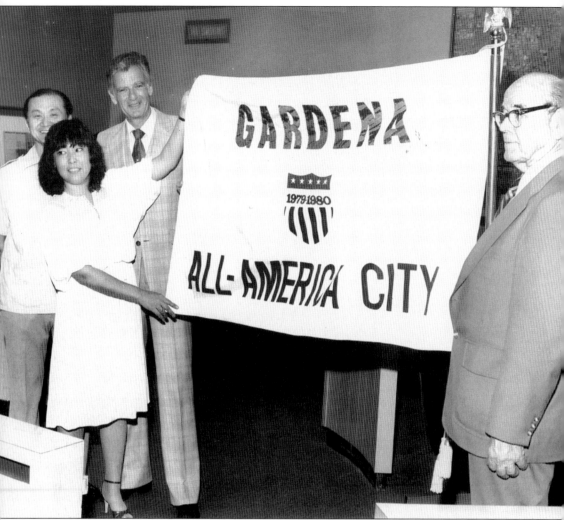

ALL-AMERICA CITY. Because of its ethnic diversity and quality of life, in addition to the community commitment seen throughout Gardena as businesses join with volunteer groups in supporting civic projects and programs, the City of Gardena earned the prestigious designation of All-America City for the year 1979–1980. That year, Gardena was the only city in California and only one of nine in the nation to receive an All-America City designation from the National Civic League. Making the presentation of the All-America City flag during the city council meeting of April 15, 1980, was Mrs. Momoyo Toguchi.